PRE-ROMANESQUE SCULPTURE IN ITALY

PRE-ROMANESQUE SCULPTURE IN ITALY

by

ARTHUR HASELOFF

HACKER ART BOOKS

NEW YORK

1971

FIRST PUBLISHED BY
PANTHEON-CASA EDITRICE, FIRENZE, 1930
REPRINTED BY
HACKER ART BOOKS, NEW YORK, 1971

THE TEXT WAS TRANSLATED FROM THE GERMAN BY RONALD BOOTHROYD

LIBRARY OF CONGRESS CATALOG NUMBER: 70-116355
SBN: 0-87817-043-X

CONTENTS

FOREWORD

In the present volume an attempt has been made to trace the artistic development of sculpture in Italy from the end of the antique period to the great turning-point about the year 1000. The author is aware that such a description, in view of the limitations of space, must necessarily be of a summary character. Much, therefore, has had to be passed over; the iconographic elements, in particular, have been treated very briefly, in the interest of a fuller elaboration of the development of style, and similarly it has been impossible to deal fully with the problems of the various tendencies of Eastern art, which had so marked an influence on Italy at this period.

A considerable part of the photographic material is based on photographs which were executed some time ago by the Department of Art History of the Prussian Historical Institute in Rome, under the direction of the author with the aid of several collaborators. This material is now in the possession of the Institute of Art History in the University of Kiel, which has accordingly been indicated as the source of the photographs in question.

KIEL, AUGUST 1930. ARTHUR HASELOFF

LIST OF PLATES

INTRODUCTION

THE history of mediaeval sculpture in Italy is to a certain degree a reflection of the political, cultural and artistic development which the territories bordering on the Mediterranean underwent during the corresponding period. When the Roman Empire was split into two halves, the geographical position of the Italian peninsula made it the natural meeting-ground for the conflicting tendencies of the eastern and western portions of the empire. The course of history brought about constant changes in political domination, and this, combined with the changes in the composition of the population which resulted from the epoch of migrations of entire peoples, made Italy the battlefield on which was decided not only the struggle between East and West, but also that between North and South. Even in ancient days there existed a sharp contrast between the Gallo-Italic inhabitants of northern Italy, the population of the central regions, and the Greeks who dwelt on the coasts of southern Italy and in Sicily; and when, after the fall of the Roman Empire, Italy was invaded from the North by migrating peoples of Germanic origin, especially Goths and Lombards, and the constitution of an Eastern Empire brought about an influx of Greeks and Orientals, similar contrasts arose, to which the Arab invasion of Sicily and other regions in the south of Italy added yet another factor.

Each of these tendencies, which can only be touched upon here, exercised a certain influence on artistic life. Of all branches of artistic activity, however, it is in sculpture that the deep-rooted contrast between the various determining influences finds its clearest expression; for the very existence of sculpture in the Middle Ages frequently depended on its connection with one or another zone of civilization. Between the downfall of antiquity and the rise of Gothic art a mighty battle was waged, which in the East, under the rule of Islam, led to the total suppression of figure-sculpture, a movement which shook to its foundations even the art of Christian Greece, while in the West the conceptions of sculpture, after a struggle which lasted centuries, finally triumphed. During the age that witnessed the transformation of architectural edifices to sculpturally completed composite buildings, sculpture usurped the role of painting, which had hitherto held the monopoly of presenting subject-matter to the spectator in pictorial form, and during the late Romanesque and Gothic periods an encyclopaedic erudition was displayed in the countless sta-

I

tues and reliefs which decorated the exteriors and interiors of cathedrals. Italy took part in this development only in certain regions and to a limited extent, but the study of Italian sculpture is rendered all the more interesting by the fact that it enables us to follow step by step the struggle for mastery between the conflicting tendencies, which in the various regions and periods pass through manifold stages of compromise, until finally one or the other tendency issues triumphant from the conflict.

This brief notice, which is intended merely to outline the peculiar position of sculpture in Italy and the attitude of Italy towards sculpture during the Middle Ages, will also serve to demonstrate the difficulties which such a study offers. The highest and lowest levels of sculptural development during the Middle Ages are found outside — one might almost say on either side — of Italy, and the development in Italy itself, varying in degree of perfection according to the region or the various external influences, follows either one direction or another.

The question of artistic relations with neighbouring countries beyond the mountains and the seas is of unusual importance in considering the history of Italian sculpture. Not content with merely recording the existence of various external influences, such as are inevitably met with when tracing the development of any artistic movement, many students of the subject have maintained that during the early part of the Middle Ages, and even more during the last years of antiquity, Italy was completely dependent on eastern art for its own artistic production. Indeed, many experts of a certain way of thinking consider that a very large proportion, if not the majority, of the artistic productions of this period were either imported, or due to workshops which were nothing else than Italian branches of the great eastern centres.

It must be admitted that the artistic relationship between Italy and the East during the Middle Ages was very close. The tracing of its development is complicated by the fact that the points of contact with eastern art are not confined within fixed limits, and the portals through which these influences penetrated into Italy did not always remain the same. These relations with the East were almost entirely maritime, and were thus not only subject to variations according to the political or economic circumstances which tended to strengthen or weaken them, but also distributed over the most diverse coastal areas; so that places so far removed from one another as Ancona and

Amalfi, Venice and Naples, Bari and Pisa, may at certain periods be found to transmit the same, or similar influences, while in addition to this, being seaports, they played an important part in the transmission not only of eastern influences but also of those of France and Spain. In the interior of the peninsula the lofty range of the Apennines formed a kind of dividing wall, on either side of which the artistic development, like the inhabitants themselves, was frequently quite different in character; but for the relationship with foreign countries this barrier had little importance, for Italy is accessible by water from every direction. Both geographical position and political circumstances were thus equally favourable to the development of close artistic relations between Italy and the countries of the East, so easily accessible by sea. The variety and complexity of the sculptural development which resulted from this mixture of so many different tendencies is astonishing. In some cases the development is the same in regions far removed from one another, while, on the other hand, conflicting tendencies may appear in neighbouring regions or even in one and the same place.

This brief sketch of the development of Italian art would be incomplete if we omitted to mention that this network of relationships had important consequences for other countries than Italy. During the period under review Italy exercised a decisive influence on the artistic development of other countries through the emigration of her craftsmen. In the sixteenth century a master-mason in the south of Germany complains that the Italian masons come to Germany like the storks in spring, to return to Italy with the approach of winter. With this anecdote Aberlin Tretsch has characterized a process the beginnings of which reach far back into the first thousand years of the Christian era; and which was certainly of considerable importance for the artistic development of well-nigh the whole of Europe during the eleventh and twelfth centuries. If it were not for the emigration of northern Italian stone-masons, the network of international artistic relations during the Middle Ages would be less closely woven than is actually the case. When we consider also how great an inspiration could and must have been received by artistically-minded travellers whose diplomatic duties or piety led them to the Holy See or to the court of the Emperors, or who traversed one of the great pilgrim-routes which led through Italy to the Holy Land, only then can we obtain a clear idea of the influence which Italy and Italian art exercised upon the Middle Ages.

THE dating of the beginning of mediaeval art is a problem which has been the subject of much discussion among historians of art during the last few decades. Classical archaeologists of earlier times were unanimous in recognizing in the sculptures on the Arch of Constantine in Rome, in so far as they were actually carved during the reign of Constantine and not taken from older monuments, so marked a deterioration of style that many have called the Arch of Constantine the tombstone of classical art. While there was a general tendency to neglect the works of the late antique period, the quality of which was not such as to claim attention from the aesthetic point of view, the productions of the contemporary Christian art, to which students zealously turned with other motives, were placed in a separate category of Christian archaeology, which endeavoured to emphasize the interest of the subjects they represented. As a consequence of this tendency the boundary between Christian archaeology and the Middle Ages remained undefined. Art historians have always paid great attention to the question of barbarian influence, which resulted from the penetration of northern peoples into the territories of the former Roman Empire, and have endeavoured to establish a definite turning-point in the history of art coinciding with the appearance of these peoples. The change of ideas which has taken place during the last few decades has had for consequence that, on the one hand, classical archaeologists are paying more and more attention to the productions of the late antique period and tend to date the end of the period considerably later, while on the other hand the historians of art endeavour to trace the origins of mediaeval art further and further back to the basis of antique art, so that the one-time distinction between pagan and Christian art loses much of its importance. In the present study we shall begin as far back as the fourth century, with a view to showing the importance of the late antique art, which has produced works of the highest importance precisely in the field of Early Christian sculpture. Naturally we do not intend nor presume to give an exhaustive account of all the various tendencies which influenced the late antique period, or even to give a description of all the most important monuments. But it would be impossible to understand the subsequent development of sculpture if we did not begin with a rapid sketch of the art of the late antique period.

I

LATE ANTIQUE AND EARLY CHRISTIAN ART IN ROME

THE position attained by sculpture in the artistic life of the Roman Empire is a matter of common knowledge, but it will perhaps be better first to give some idea, by quoting a few examples, of the abundance of works of art which were erected in public places and in private houses. When we are told by Pliny that the theatre of Marcus Scaurus contained no less than 3000 bronze statues arranged among its pillars, and when we read in the *Narratio de Ornatu Romae* by Bishop Zacharias of Mytilene that 3785 bronze images of emperors and other military leaders could be counted in the city of Rome, it becomes almost impossible to conceive the vast number of marble statues which must have existed in Rome itself, let alone in the whole of Italy. It is hard to understand why of all these masses of works so few have been preserved. The information given by Pliny and Bishop Zacharias gives us an insight into two features of sculptural creation at the time of the Empire: firstly, the use of works of sculpture for ornamental purposes, which in the absence of originals were supplied for the most part by the copyists who flourished during the Roman period; and, secondly, the prevalent usage of erecting sculptured likenesses of contemporary personages, closely connected with the custom of commemorating in sculptured monuments the great deeds of the nation, its armies and its leaders, which is so characteristic of the whole Roman era.

The above remark may be taken as a reference to the celebrated series of reliefs so typical of Roman art, such as have been preserved to us, to name only the best-known examples, on the columns of Trajan and Marcus Aurelius. These reliefs deal with historical subjects, and sculptural representation offered at that time a solution of a problem which in modern times can only be given by the cinematograph, by panoramic painting or by the illustrations contained in books. In these works dealing with historical subjects Roman art found full employment for its creative powers, and it is for this reason that such works are the first to attract the attention of modern students of the subject. The interest of this group of historical works, including the corresponding productions of the minor arts, is enhanced by the fact that the

5

greater part of these monuments can be dated at least approximately. They thus serve as a starting-point for the study of the undated works, and as the series of such historical works, among which we may also reckon the portrait-statues and busts, brings us, despite the many regrettable gaps, down to the sixth or seventh century, it is obvious that they represent very valuable points of reference for the dating of Christian monuments, the close connection of which with the secular, pagan art becomes more and more evident.

As we said above, the Arch of Constantine has been considered for centuries as a kind of boundary-stone of antique sculpture. Its reliefs reveal, as Burckhardt has observed in his *Cicerone,* "the bankruptcy of the art of relief and of sculpture in general". Apart from the question of the value of these reliefs, it is certain that with the beginning of the fourth century a new period in the history of late antique art set in, which possesses a distinct original character of its own when compared with the preceding phases of stylistic development. Despite this, it is difficult to define these peculiar characteristics with the same precision and uniformity as is possible in the case of the periods of Augustus and Antoninus. An examination of a few selected examples of monuments, the connection of which with the personality of Constantine and his age is unquestionable, will suffice to show the contrasts between the various tendencies which modern research is bound to take into consideration. If we take as a starting-point the portrayal of the emperor himself, we are bound to admit a distinct retrograde tendency in the few heads or statues which have come down to us, such as the head in Berlin and the statue from the *thermae* of Constan-

Plate 1 tine which is now in the atrium of San Giovanni in Laterano. This tendency is a kind of classicism which goes back to models of the Augustan period and which has been termed Neo-Augustan. We shall deal later with this "renaissance augustéenne sans lendemain" as Salomon Reinach once called it, which may be followed down to the beginning of the fifth century. Its retrograde character, however, is found only in a few monuments, while in the majority of heads which have been preserved from the time of Constantine and from later periods, tendencies of a completely different nature may be noticed. In a study of the head of Constantius Chlorus in Munich, Sieveking draws attention to the mask-like rigidity, excluding all human, individual characteristics, the immobility of the features, and the wide-opened eyes which seem to be staring into the far distance. It should of course be borne

6

in mind that these characteristics do not by any means signify a lack of ability on the part of the artist. On the contrary they appear to be deliberate. These portraits of emperors are based upon an entirely different conception of the method of representing a ruler, according to which majesty must be represented in carefully calculated movements, producing an effect of superhuman magnificence by avoiding everything which is not ceremonial and solemn. This explains the preference for huge proportions (the colossal head of Constantine the Great from the Maxentius Basilica, one of the chief examples *Plate 2* of this tendency, is nearly nine feet high!). These gigantic dimensions, which make it a necessary condition that the monuments should be seen from a distance, were bound to have a considerable influence on the expression of form. It must be clearly understood that it is impossible to obtain a correct idea of these works when we see them in their present positions, so different from the conditions under which they were originally intended to be seen. We should like, however, to make it clear that, despite the characteristics mentioned above and despite the solemnity of the representation, neither the individual element in the external appearance nor the inner conception has been sacrificed. The heads named all bear the imprint of a deep and passionate feeling, and even of a certain wildness, which produces a striking effect on the spectator and gives a vivid impression of the tense existence of the rulers of that period. It is precisely for this reason that many of the heads of the later periods produce so impressive an effect on the modern spectator, despite the decreasing ability of the sculptor, which becomes more and more obvious as times goes on. At this point we may mention that Rodenwaldt, speaking of a series of late antique heads of philosophers, ventured to draw a parallel between them and Van Gogh's portraits. It is certainly true that a large number of heads from the late antique period might be accused rather of an excess of expression than of a mask-like coldness.

Of all the long series of late portraits of rulers which have been brought to light, thanks to Delbrueck's careful researches, during the last few years, we will only mention, as a confirmation of the characteristics we have mentioned above, the so-called Constans I in the Palazzo dei Conservatori and the Co- *Plate 3* lossus in Barletta, identified by Koch as a statue of Valentinian I (364-373), in which, however, Johnson recently claimed to recognize a statue of the Emperor Heraclius dating from the year 628 or 629, a supposition which is rather *Plate 4*

improbable. The magnificent portrait-head in Milan, equally fine in execution
Plate 5 and filled with the same power of expression, which probably represents the
Empress Theodora, proves beyond all doubt that the tendency mentioned
above continued to produce masterpieces even down to the sixth century. It
is true that such eminent achievements were not very frequent, and that
in addition to them a large number of works of inferior quality has been
preserved. The sixth century, which was an eventful turning-point in the
history of sculpture, at all events in Italy, probably marked the end of these
large sculptured portraits.

We have already mentioned above that special circumstances, such as the
enormous dimensions and the position the statues were to occupy, may well
have had a deciding influence on their artistic formation. The materials used
must also have exercised a very considerable influence in this direction, and
Rodenwaldt is certainly right in trying, by means of a study of the materials,
to distinguish in the art of the period a "courtly" element which may be traced
back to the days of Constantine. The magnificent sarcophagi in which the
Empress Helena and her daughter Constantina appear to have been buried,
but which, according to a not improbable supposition, were originally inten-
ded for Constantius Chlorus and Constantine himself, were of porphyry, a
very significant circumstance. Although the reliefs which decorate these sar-
cophagi are quite different in character, representing in the one case scenes of
battle and in the other *putti* gathering grapes, there is no valid reason for
disputing Rodenwaldt's attribution of the two monuments to the age of
Constantine. These sarcophagi were probably made in Egypt, where the por-
phyry which was so popular for figures or tombs of emperors was quarried.
A further proof of this is the fact that fragments of similar sarcophagi have
been preserved in Alexandria and Constantinople. Another series of very im-
portant works in porphyry, preserved in Venice and Ravenna, also seems to
Plate 8 be of Egyptian origin. One of these is the statue of an emperor, unfortunately
without the head, in Ravenna, which perhaps belongs to the end of the fourth
century. It occurred to Conway that the porphyry head of an emperor on the
Plate 6 parapet of St. Mark's at Venice, popularly known as "Carmagnola", might
have belonged to this statue. Although this supposition has proved to be in-
correct, Conway was probably right in assigning this head to the same period
as the torso in Ravenna. Delbrueck has claimed to see in the porphyry head a

8

portrait of the Emperor Justinian II Rhinotmetos (705-711), but his assertion that the features are those of the emperor, with the nose disfigured, does not seem to us very convincing. On the contrary the head appears to us to be very similar, as regards the representation of the nose, to the well-known groups in *Plate 7* porphyry of knightly figures embracing one another, to be found at the corner of St. Mark's, and commonly supposed to represent the sons of Constantine; according to more recent opinion, however, they represent Diocletian and his fellow-rulers. We thus have good grounds, quite apart from the improbability that a sculptor of the late seventh or early eighth century would have attempted to represent the disfigured features of an emperor with realistic fidelity, for attributing this head to a period approximately coinciding both with the statue in Ravenna and the above-mentioned pairs of figures in Venice. Even if we leave aside this debatable point, this group of porphyry sculptures remains of the utmost importance, for it is an example of a particularly hard and stiff style. The difficulty which the carving of such a material offered inevitably resulted in such a stylization. Egyptian tradition may, as Strzygowski has remarked, have had its share in these works. In any case, we are convinced that the fashionable demand for magnificence, which brought with it the preference for porphyry, resulted in the penetration of a foreign element of style, and therefore exercised a certain influence on stylistic development.

If we now turn our attention to the reliefs on the Arch of Constantine, it is *Plates 9, 10* clear that, after all that has been said above as to the century-old habit of depreciating the value of these reliefs, there can be no question of their representing a Renaissance tendency, such as we started from in our consideration of sculptural portraiture. Riegl, as is well known, attempted to contradict the general opinion of these reliefs, by asserting that what is commonly considered as a deterioration of style is really an endeavour to attain a new ideal of beauty, which is of the utmost importance for the subsequent development of sculpture. Whereas the majority of the reliefs on the arch, such as, for example, that representing the battle at the Pons Milvius, show a preference for dramatic events and for moving figures, with the action developing in irregular stages in the form of a frieze, the arch contains two scenes, one representing an imperial address and the other a distribution of bread to the people, in which the atmosphere is one of a solemn state event. The principal figures are arranged in accordance with a strictly-observed etiquette, and this stiff

9

and solemn arrangement is even extended to the spectators who are presented with the same variations of position and attitude in each group, in strict accordance with the theory of correspondence between the left and right sides of a scene. These carvings, the originality of which is rendered all the more striking by the fact that they stand side by side with reliefs from the second century, emphasize the contrast between the schematic stiffness of the newer style and the easy freedom and elegant attitudes of the older reliefs. The new manner, which Riegl maintains to be a seeking-after a crystallized ideal of beauty, is undoubtedly a first step towards the mediaeval theory of composition.

The new element in these reliefs, however, lies not only in their composition but also in the stylistic treatment, which is also in violent contrast to that of the second-century works. The figures of the Constantine reliefs are no longer modelled in the round but are to a certain extent defined by sharp cutting, and the modelling, especially as regards the draperies, is correspondingly simplified. The endeavour to attain round modelling of the figures is replaced by the incision of deep grooves. This mode of treatment results in a linear effect to be compared with the results obtained in a graphic representation, in which the dark streaks with their play of shadow throw into relief the outlines of the figures. It is clear that such a method was bound to produce a great effect when applied to reliefs placed high above the ground beneath the brilliant light of a southern sun. The eye of the spectator could easily complete unaided what with other methods of treatment could only have been obtained by a careful modelling.

Considered separately, neither the method of composition nor the stylistic treatment would suffice to explain the indignation of the classicist critics; but in addition we have to face the fact that the reliefs were executed by obviously unskilful and clumsy hands. These defects, however, ought not to be regarded as typical of the average capabilities of artists of the period, and their presence on an official monument of such great importance and in so prominent a position is a riddle which it has hitherto been impossible to solve.

Rodenwaldt has attempted to give a new explanation of the origin of the peculiar characteristics to be seen in the reliefs on the Arch of Constantine, characteristics which can be found again in numerous sarcophagus-reliefs of the period. He perceives in them a popular tendency combined with a marked leaning towards realism, and notes their close relationship with other artistic

productions in the Roman provinces and especially in Gaul. He even ventures to assert that this provincial art may have been brought to Rome by Constantine from the banks of the Moselle. Whether this theory is correct or not is a question which we may leave aside. The important point is, that Rodenwaldt thereby draws our attention to the peculiar stylistic forms which can be verified in all the provinces of the Roman empire. We shall return later to the question of the degree to which this provincial art may be considered a fore-runner of mediaeval art from the moment when the dependence upon artistic tradition begins to weaken and a departure from the forms of Graeco-Roman art sets in. The history of the provincial art of the Roman Empire and of its importance for the origins of mediaeval art is as yet unwritten.

THE above remarks do not pretend to be more than a brief guide to the history of late antique art. They are intended to show the difficulties which beset our path when we attempt to unravel the network of development by an examination of the few monuments which have been preserved to us. It is precisely when we turn to the examination of so important a group of monuments as the Early Christian sarcophagi that it becomes important to remember that we cannot hope to establish a uniform line of development from the antique period down to the Middle Ages, but that we shall have to deal with the most varied tendencies and influences coming from all quarters.

The Roman group of Early Christian sarcophagi, the number of which is generally given as 256, represents the most important collection of sculptural monuments that has come down to us from this period. In many cases the state of preservation is not as good as we might wish, and much damage has been caused by ill-advised restoration or completion. It is particularly to be regretted that we possess very few remains of the painting which formerly covered the sculptures on the sarcophagi, and must once have constituted an important feature of such works; we are thus quite unable to form an opinion as to the exact effect which the artists wished to produce.

We have spoken above of the difficulties which a study of this subject involves, and therefore it is not surprising that the most contradictory assertions are to be met with regarding the dating, the stylistic classification and the place of origin of these sarcophagi. Notwithstanding the large number of sarcophagi, we find remarkably few definite clues which assist us to give an

answer to these questions. It is only in exceptional cases that they bear inscriptions which give a clue to the persons buried in them and the period at which they lived, and even when such inscriptions with definite indications do exist, they cannot be relied upon to any great extent, for the possibility that the sarcophagi were used several times cannot be excluded. In addition to this, the fact of having established the identity of the individual buried in the sarcophagus and the date of his death does not necessarily mean that the problem of the place of origin, or still less that of the stylistic classification of the ornamentation has been solved. Although the Roman sarcophagi show a certain uniformity of style, in so far as the majority of them are to be found in or near Rome, while similar works with very few exceptions occur only in Italy, and outside that country can only be related to the Provençal group of Gallic sarcophagi, the sarcophagi found in other regions being quite distinct in form, it has nevertheless been maintained that a large part of the Roman sarcophagi was produced in workshops of the Christian East and then brought to Rome. The more cautious investigators, impressed by the fact that up to the present no examples or fragments of similar sarcophagi have come to light in the East, have attempted to give another explanation of the problem by attributing these monuments to workshops established in Italy or in Rome itself by sculptors who had immigrated thither from the East.

The investigations on this subject are at present only in the embryonic stage. The main part of Wilpert's work on Christian sarcophagi has yet to be published. Moreover, definite conclusions as to the existence of such workshops at certain places and periods will only be possible if a thorough study of both the eastern and western regions, and of heathen as well as of Christian sarcophagi, gives uniform results. Endeavours to attain this end have not been lacking; Rodenwaldt, to whose researches we have so frequently referred, has rightly drawn attention to the oft-established fact that Christian and heathen sarcophagi must often have been produced in the same workshops.

The reliefs on the Arch of Constantine, the artistic importance of which we have already had occasion to emphasize, are a very good point of departure for such a study, for groups both of heathen and of Christian sarcophagi may be brought into relation with these reliefs. Among the Christian sarcophagi thus related there are many the front of which is adorned with a representation of the Passage of the Red Sea. The sudden popularity of this subject has been

explained as a result of the parallel which was drawn at the time between the swallowing-up of Pharaoh in the Red Sea and the victory of Constantine over Maxentius at the Pons Milvius. This theory finds confirmation in the literature of the period. The sarcophagi in question are not the oldest specimens of Christian sculpture of this kind, which must date from as early as the second century, but they all possess the marked peculiarities of the Roman group, that is to say, they are not very high, have flat lids, and are evidently intended for erection in a tomb, for which reason they are only decorated on three sides. The front is generally covered with a frieze-like ornamentation, and in Christian sarcophagi it is the exception rather than the rule if this frieze deals with only one subject. The type generally preferred in Rome consisted, on the contrary, of a number of different subjects represented on the front of the sarcophagus without any external divisions and only slightly held together by the connection of ideas. In very elaborate specimens this frieze is sometimes doubled by a second frieze placed above the first. Frieze-sarcophagi of this type appear to have been extremely popular in Rome so long as the sculpture of sarcophagi remained a flourishing art.

Plate 11

Whereas the frieze-sarcophagus represents the type of which the Roman origin is least doubtful, things are far more complicated when we come to the so-called column-sarcophagi, that is to say, sarcophagi in which the narrative content of the decoration is separated according to the various subjects by arcades, arranged like the friezes in two rows. Most of the sarcophagi of this class retain the traditional western form, being decorated on three sides only, but there exists a whole series of particularly noteworthy and sumptuous examples which follow the Greek custom of decorating the sarcophagi on all four sides, with a view to their being seen from all directions, while in addition to this they are surmounted by a lid having the shape of the gables found on houses. As is well known, the column-sarcophagus is to be found in unusually large numbers all over Asia Minor. The sarcophagi of this type which have been preserved are among the most beautiful that the art of the period has handed down to us, but of those hitherto discovered in the East only one, and that a fragment, is of Christian origin. The Roman column-sarcophagi, heathen examples of which may be found as far back as the beginning of the third century, are of a far more modest nature. The Christian column-sarcophagi retain for the most part the traditional Roman form and generally date from the fourth

13

or fifth century. It must be admitted, however, that specimens which can be dated with certainty are lacking; and the celebrated masterpiece of this class, *Plates 12, 13* the sarcophagus of Junius Bassus, prefect of the city, who died in 359, has long been the subject of dispute as to whether the date of the prefect's death coincides with that of the origin of the sarcophagus, or whether it is merely a case of the sarcophagus being used for a second time. The carvings of this monument are arranged in two rows under arcades, and represent scenes from the Old and New Testaments loosely connected with one another. Their importance from the point of view of the history of style is considerable, for they are in direct contradiction with the style of the reliefs on the Arch of Constantine, for which reason many investigators have been induced to assign them to an earlier epoch. The standing figures, which are never very numerous, in the foreground of the composition on the Junius Bassus sarcophagus are carved almost in the round, so that they stand out from the background and produce a strong effect of shadow. The figures are carefully modelled and in this respect too are quite distinct from the vague style of those on the Arch of Constantine. It appears to us quite inadmissible either to date these sarcophagi from a preceding century or to maintain that they are outside the normal development of Roman artistic development. The variety of styles employed in Rome for reliefs at this period is proved by the fact that, while the ends of the Junius Bassus sarcophagus are decorated with genre-like harvest scenes, those of the well-known column-sarcophagus in the Lateran Museum showing the Giving of the Law are covered with pictorial reliefs of an entirely different character.

Far greater difficulties are presented by that other group of column-sarcophagi, which has been attributed to a Vatican workshop because several specimens have been found in the neighbourhood of the Vatican. On account of their peculiar architectonic background they have been styled City-Wall sarcophagi (the latest student of this group, Marion Lawrence, calls them City-Gate sarcophagi). In their sumptuousness and size they are among the most impressive productions of the Early Christian period and break with the Roman tradition of decorating sarcophagi on three sides only. They are by no *Plates 14, 15* means confined to Rome, for specimens also occur in Milan, Ancona and in Tolentino, while numerous imitations may be found in Gaul. The subject of the chief picture is generally the Saviour as Lawgiver surrounded by the Apos-

tles. The figure of Christ, in contrast to the more usual youthful and Apolline type, has a long beard and thick, flowing hair, and is of surprising majesty. It is easy to understand that these unusual characteristics have given rise to doubts as to the Roman origin of the group; but even the careful investigations of Marion Lawrence can only lead to the conclusion that these sarcophagi were certainly intended for western use; so that even Marion Lawrence cannot exclude an Italian origin, although she maintains that they were the work of Asiatic artists. The close relationship of this group of sarcophagi with the West is also confirmed by the fact that similar groups show a clear transition to the Roman type of frieze-sarcophagus. This is especially true of the "palm" and "city-wall" sarcophagi and the "Bethseda" group, and Marion Lawrence would like to add to these the sarcophagi on which the Passage of the Red Sea is depicted. The principal specimens, in view of the fact that many of the persons buried in them lived in the last quarter of the fourth century, probably date from the end of the latter century or the beginning of the fifth.

Another question which has given rise to much discussion is that of the duration of the flourishing period of Roman sarcophagus-sculpture. It seems certain that this art died out without having undergone any considerable changes of style, and without any transition to other forms such as may be observed elsewhere. This explains the origin of the theory that the production of sarcophagi in Rome suddenly ceased. Frothingham advances the hypothesis that the sudden cessation of workshop activity was a consequence of the emigration, almost resembling a flight, of the artisans during the period in which the menace of an invasion of the Goths first began to appear, that is to say, about the beginning of the fifth century. If we wish to obtain a proper insight into the significance of this supposed exodus of Roman artists, we must first consider another branch of artistic activity in Rome during the late fourth and fifth centuries, that of ivory-carving, of which we still possess a comparatively large number of specimens. We may add that such a study also serves to throw light on other aspects of the question, and in ivory-carving, as in sarcophagus-sculpture, it is equally impossible to classify the various groups of works in accordance with a definite line of development.

With the ivory workshops we have at least the advantage that we can start from examples which are easy to date and the subjects of which show their connection with Rome, or at all events with high Roman dignitaries or fam-

ilies. The ivory diptychs which, in accordance with a century-old custom, the higher officials, and especially the consuls, were wont to present to their friends on taking office, constitute excellent points of reference. The connected series *Plate 16* of works begins with the diptych of the Nicomachi and Symmachi (in London and Paris), which must belong to the last period of heathen worship in Rome. According to the older theory, this diptych dated from the time of Quintus Aurelius Symmachus and Virius Nicomachus Flavius, both of them followers of the pagan religion, that is to say between 376 and 394, while Delbrueck has recently expressed the opinion that the priestess is Galla, a daughter-in-law of Quintus Aurelius Symmachus and a member by birth of the Nicomachi family, in which case the date would be shortly after the year 400. For the purposes of our study, however, the artistic value of the diptych is far more important than the interpretation of the subject represented, for the carver has succeeded to a surprising degree in reproducing the style of Hellenistic models. This "almost incredible" purity of style is absolutely in accordance with one of the chief characteristics of late antique art. Here we have to do with one of the purest productions of that Renaissance movement to which recent writers, in connection with the similar movement perceptible in the poetry of the time, have given the name of "Claudian" art, after the heathen poet C. Claudianus. That adherents of the pagan religion should endeavour to rescue or revive even art with a return to classical culture is easy to understand. At the same period Theodosius the Great declares in an edict that the pagan "simulacra" are "artis pretio quam divinitate metienda", that is to say, that the artistic value of the pagan images is to be considered no matter what the religious significance. It was during this same period that the images were removed from the temples, to prevent their being worshipped by the followers of the pagan faith, but at the same time were publicly exhibited for the sake of their artistic value and under the names of the respective artists. This trend of ideas corresponds exactly with the rather retrograde stylistic tendency of the Nicomachi-Symmachi diptych, to which a whole series of other diptychs may be related, such as the consular diptychs of Probus (406) and of Felix (428), *Plate 17* and above all, those of the city prefect Rufius Probianus, now in Berlin, and of the Lampadi family in Brescia, which cannot be dated with exactitude.

It is also very significant that a number of ivory tablets depicting Christian subjects shows a close relationship to these productions of secular art, a rela-

16

tionship which the writer attempted to demonstrate many years ago, and which has received full confirmation from the most recent studies of Baldwin Smith and Edward Capps. The most important specimen of this group is the diptych in the Trivulzio collection, representing the Holy Women at the Tomb, *Plate 18* in which important similarities both of *ensemble* and of detail may be perceived with the above-mentioned secular diptychs. Very similar to the Trivulzio diptych is the so-called Reider tablet at Munich, which depicts the Resurrection *Plate 19* and Ascension of Christ. These two works, around which numerous others may be grouped, appear in their purity of style and their excellence of execution just as "incredible" for the period in question as the secular diptychs.

When the decay of style started is difficult to establish with any certainty. The Roman consular diptychs of Basilius (480, now in Florence) and of Boethius (487, now in Brescia), show that the zenith of the art had already been *Plate 20* passed. On the other hand, these two diptychs show close resemblances to another important work of Christian ivory-carving, namely, the diptych in five parts in the treasury of Milan Cathedral, which corresponds to the Boe- *Plate 21* thius diptych even down to the details. The connection with Roman families and with consuls of the Western Empire, which can be established more or less in accordance with the progress of their development down to the latter half of the fifth century, must inevitably lead us to suppose that the workshops in which these ivory reliefs originated must have been situated in Rome or at all events in Italy. And yet, despite the hypothesis advanced by Stuhlfauth as to the existence of a school in Milan, Baldwin Smith, basing his assertion on iconographic observations, has recently maintained that although this group may have originated in Rome and be intimately connected with Roman development, nevertheless the school, as early as the beginning of the fifth century, must have been transferred to Provence, probably to St.-Victor at Marseilles. In this case too, the explanation given of this surprising emigration is the fear of the artists of a Goth invasion.

The problem which we have to solve regarding ivory-carving is the same as that with which we are confronted in our study of sarcophagus-sculpture. It is a well-known fact that the Provençal sarcophagi are very closely related to those of Rome. In his investigation of this problem Rodenwaldt arrives at the conclusion that the credit for the origin of these sarcophagi must be given to Rome, as no evidence of the previous existence of such works in Gaul is forth-

coming. It thus remains to determine whether ready-made sarcophagi were imported from Rome, or whether branches of the Roman workshops were established in Gaul. That there was great activity in the art of sarcophagus-sculpture in Provence during the fifth century cannot be doubted. But we are equally averse to accepting either the hypothesis of a sudden cessation of Roman marble sculpture about the year 410, or that of an emigration *en masse* of the ivory-carvers. The later works are so closely related to the subsequent development of Roman life, that even Baldwin Smith had to consider the possibility of a return of the artists to Rome. More recently both Berliner, in the course of a study on the Von Reider tablet, and Delbrueck reject the theory according to which the chief productions of ivory-carving must have originated in Provence. In the words of Delbrueck, Gaul was merely "the passive export market for the ivory production of the south-east, in which wandering artisans from Alexandria or Syria were sometimes to be found".

Plate 22

It must be admitted that the development of Roman art during the fifth century still presents a number of insoluble riddles. A typical example is furnished by the wooden doors of Santa Sabina in Rome, a monumental masterpiece of the period, which have been judged in the most varied ways. It was a very long time before their Early Christian origin (contemporary with the founding of the church in 430) was recognized. Since this date has generally been accepted by the majority of investigators, the place of origin has furnished another question for dispute. Since the days of Ainalow it has been held that the reliefs show such strong resemblances to Syrian art that it is legitimate to suppose that they may have been made in Syria or by Syrian artists living in Rome. As a matter of fact, the various panels of the doors, which represent scenes from the Old and New Testaments, display a number of different stylistic tendencies. In one of the panels the figures are arranged in rows after the manner of certain sarcophagus-reliefs; in another the composition is divided into several superimposed strips (as, for instance, on the Probianus diptych); a third shows a tendency towards depth which can only be explained as a derivation from painted models. On a par with the stylistic peculiarities are the curious iconographic features, as seen in the celebrated representation of the Crucifixion. A definite explanation of the problem of these doors is at present impossible, for they present such a number of different tendencies of style that V. Schultze in a recent study was inclined to assign

the various groups to different periods. As we firmly believe that these doors originated in Rome, their importance becomes all the greater, for they serve to give us an idea of the varied nature of Roman art at that period, an art of which at present we have only a limited knowledge.

II

SPOLETO AND THE CLITUMNUS TEMPLE

Plates 23, 24

IN the brief description of the development of Early Christian sculpture which we have endeavoured to give in the preceding pages, we have omitted to speak as yet of one important branch of plastic art, namely, the employment of sculpture in connection with the ecclesiastical buildings of the period. As a matter of fact, no churches are to be found in Rome which can show the elaborate sculptural decoration of the façades so frequently found in Syria during the centuries of the Early Christian era. At this stage of our studies, however, we must mention two monuments which occupy a unique place in the history of Italian art of the period and, while they represent the nearest parallels to the Syrian ecclesiastical buildings to be found on Italian soil, also appear to be intimately connected with the development of native Italian art. The first of these two monuments is the church of San Salvatore or Il Crocefisso, near Spoleto, a building which, to start from its architectural design, a domed basilica, is a rarity on Italian soil; and the question as to its relationship with the development of architectural construction in the East cannot fail to present itself immediately. This building has an elaborate façade adorned with sculptural decorations the like of which are not be found in all the rest of Italy. The façade itself, with its three portals on the ground level and its upper storey divided by pilasters — only the engaged blocks have been preserved; the greater part of the decoration must have been in stucco — at once reminds us of Syria. But, thanks to the painstaking investigations of Hoppenstedt, we know that although this decoration presents one feature, namely, a kind of radiating finial, which bears a very strong resemblance to the topes frequently found in Indian art, "all the other *motifs,* and even their internal arrangement and the entire architectonic system..." are completely in keeping with the development of Roman art. The choice of forms which we see in the acanthus-foliage with its large blossoms can be traced back to the early period of the Empire, the only period which produced such finely-conceived foliated ornamentation. Hoppenstedt dates the building from about the year 400 — an opinion shared in more recent times by Salmi — and explains the highly unusual architectural form by reference to that Renaissance

20

tendency in Roman art which we have already mentioned several times. De Rossi had already defined this church as "la più classica delle chiese super-stiti dei primi secoli". The Basilica of San Salvatore, however, ought to be considered together with that other miracle of Early Christian art which is to be found not very far from Spoleto, the Clitumnus temple near Trevi (in the neighbourhood of the source of the Clitumnus). This latter building is in its *ensemble* so similar to an antique temple, that numerous investigators have been unwilling to believe that it can represent anything but an Early Christian, or even mediaeval, transformation of a pagan building. Hoppenstedt's investigations, however, have proved that a uniform Christian design may be traced, which nevertheless departs completely from the traditions of good Roman architecture in its inorganic and variegated character. The most important features for us are the ornamental reliefs on the gable-end, of which we find a "rather careless workshop repetition" on the wall of the choir, and the internal decoration of the wall of the apse. A comparison of the three portions mentioned shows that considerable differences of style exist. The contrasts are, in fact, so striking that we seem to see in them the whole transformation of artistic ideas from the antique period down to the Middle Ages. While the front is similar to that of San Salvatore, the gable-end of the back wall seems a clumsy and coarse repetition, and in the interior a complete transformation of the foliated decoration is effected, for not only do the large and beautiful blossoms disappear, but also the distinction between stalks and leaves. The impression created is that of a rapid and constant approach to the Middle Ages, and yet it seems that this temple and its decoration date from the fifth century, for Hoppenstedt has successfully defended the age and uniformity of style of the building against attempts to assign to it a more recent date, such as have been made, for example, by Grisar. If we exclude the Lombard and mediaeval copies and imitations, the decoration of the churches in Spoleto and Trevi stands alone, and offers problems to investigators the solution of which is scarcely furthered by references to numerous points of resemblance with Syrian art, which might perhaps be confirmed by a study of the religious history of Umbria. On the other hand the deliberate resemblance to Roman models of the classical period is in contradiction with all other systems of ornamentation the penetration of which from the East we are able to follow, and can only be compared with the Renaissance tendency which existed in Rome.

Plates 25-27

21

III

RAVENNA

OUR knowledge of monuments and the progress of investigation do not yet allow us to establish to what extent the remaining cities and regions of Italy followed a similar, identical or diverse course of development during the same period. Even for important cities like Milan we are not yet in a position to give a definite answer, although this city has preserved so important a monument as the carved wooden doors of the church of Sant'Ambrogio. This lends still greater importance to the fact that in Ravenna we possess a series of monuments which, like those of Rome, form a definite artistic whole. We must, however, admit that the correctness of this assertion depends largely upon the dates which we can assign to the Roman group on the one hand and to that of Ravenna on the other. We have already seen that the fourth century of our era witnessed the zenith of Roman sarcophagus-sculpture and we have further explained the reasons which seem to us to render improbable the theory advanced by individual American investigators as to the complete cessation of the practice of the art in Rome about the year 410 in consequence of a supposed exodus of artists to Gaul. On the contrary, everything seems to point to a continuance of Roman artistic activity well on into the fifth century, with consequent preservation of the old traditions. We shall speak later of the pause which occurred in the line of development. As regards the dating of the Ravenna monuments, we can find reliable points of reference in the history of the city. Ever since the time of Augustus, Ravenna had been an important seaport, but it reached the summit of its importance at the time when the Goths were threatening Italy, and Ravenna, protected on the land side by its marshes, became the official residence of the Western Roman emperors (402). After the fall of the empire the Ostrogoth kings made Ravenna their capital and when the town was captured by the Byzantines in 539, it became the seat of the Byzantine exarchs, until in 741 it was conquered by the Lombards. The height of Ravenna's prosperity thus lies in the fifth and sixth centuries, and for this reason alone it is not very probable that the zenith of the art of sarcophagus-sculpture can be assigned to an earlier period, as some writers have tried to do by arbitrarily re-dating the monuments which

have been preserved. If the opinions set down in the present volume are correct, the art of Ravenna must have reached its zenith approximately at the period in which Roman art was beginning to decline, but for a long period the art of each of these two cities followed its own, separate lines of development.

The brief remarks on the historical importance of Ravenna given above will already have sufficed to indicate the direction towards which we have to look if we wish to seek an explanation of the development of art in Ravenna. The face of Ravenna was turned towards the East; and Strzygowski once described it as the outpost of Aramaic art in the West. As a seaport, Ravenna was in close touch with the Eastern Roman empire and with the Orient, and to this connection it owed its importance and its prosperity. After the Lombard conquest it sank to the level of a provincial town and played no further part in the development of art.

The Eastern influence is particularly evident in the field of sarcophagus-sculpture. Even in pagan times there existed in this eastern portion of northern Italy numerous sarcophagi decorated on all four sides and closed by a gable-shaped cover, although it must be admitted that the ornamentation was generally of a very simple kind. The same type of sarcophagus continued to be produced during the Christian period, but the gable-shaped cover was replaced in almost every case by barrel-shaped lids. It is very seldom that we find in Ravenna sarcophagi of the type produced in the city of Rome. We therefore find a development which, when compared with that of Roman sarcophagi, is seen to possess definite characteristics of its own; and this serves to emphasize even further the individuality of Roman art.

That the dating of the Ravenna sarcophagi offers a number of difficult problems and leaves room for many different hypotheses, has already been stated. It is true that numerous sarcophagi in Ravenna bear inscriptions or else are defined by tradition as the tombs of certain members of the imperial family, of exarchs, archbishops etc., but the certitude which these data would appear at a first glance to provide has been shattered in numerous cases as a consequence of modern investigation. Italian savants, under the guidance of Corrado Ricci, have made a particularly thorough examination of the problems connected with the art of Ravenna and have drawn attention to the discrepancies existing between the historical data, which make no mention of

23

burials inside churches in sarcophagi standing above the level of the pavement, and the actual state of affairs. The study of the sources of documentary information makes it quite certain that in the Middle Ages removals and exhumations of skeletons were frequent and this fact naturally changes our whole outlook on the question of origins.

The uncertainty thus created affects in particular the supposed sarcophagi of the imperial family in the Mausoleum of Galla Placidia, from the study of which it was hoped to arrive at definite results, which would be of the greatest importance for the whole question of the development of mediaeval sculpture. Riegl, for example, having observed that the three sarcophagi in the Mausoleum of Galla Placidia contain no representations of human figures, considers this sufficient justification for the far-reaching conclusion that not only in Ravenna but also in Rome "the carving of figures in stone, as far as religious subjects were concerned, practically ceased from the time of Honorius onwards". Similar conclusions, though based on other grounds, among which the high quality of Ravenna sarcophagus-sculptures occupies an important place, were reached by Dütschke, who would like to date a large part of the Ravenna sarcophagi much earlier and some of them even as early as the second century. Goldmann, on the contrary, in a study of sarcophagus-sculpture in Ravenna, believes that the sarcophagi in the Mausoleum ought to be assigned to a much later period, a view shared by Ricci, at least as far as the Constantius sarcophagus is concerned. The difficulties which thus arise cannot easily be definitely solved. Writing in the ninth century of the tomb of Galla Placidia, Agnellus could only tell us that she was buried in front of the altar, between the chancels — in which case the sarcophagus cannot have been above the pavement. The sarcophagus, which according to a later tradition, contained the body of Galla Placidia is of unusually large size, but completely lacking in decoration, except for the remains of a half-obliterated "tabula ansata" which may still be discerned on the front. Curiously enough, the older descriptions are particularly loud in their praises of the magnificent decoration of this sarcophagus, a contradiction which can only be explained by the hypothesis that at that time the sarcophagus was enclosed within a richly-decorated involucrum. Both the "Constantius" and "Honorius" sarcophagi have only symbolic ornamentation. A feature common to both is that the ornamentation of the sides is dissimilar and in the Honorius sarcophagus

is only partially completed. A similar state of incompleteness is not un-common, but when, as in this case, the undecorated or incomplete parts are the backs of the sarcophagi — which in one of the two examples under consideration is quite smooth and in the other has been left unfinished — and when in addition to this we see that the narrow end furthest away from the entrance has in the one case been quite superficially treated and in the other left incompleted, we are bound to assume that in the preparation of these sarcophagi great importance was attached to their being completed in the shortest possible time, and that in view of the position the sarcophagi were destined to occupy the less important surfaces were left bare of orna-ment or unfinished, an observation which it is certainly difficult to reconcile with the above-mentioned results of Corrado Ricci's investigations. However that may be, the fact remains that the imperial sarcophagi constitute very un-certain points of reference for the purposes of dating. They ought not to be used as a basis for the classification of sarcophagi into the older group, on which figures appear, and the more recent, in which the decoration is confined to mere ornament; for an examination of the Ravenna sarcophagi shows that the ornamentation found on the backs and ends of sarcophagi on which re-presentations of human figures are seen is in complete accordance as regards style with the group of purely ornamental sarcophagi. This concordance of style is so great that some writers, in order to preserve the classification into two groups, have maintained that the ornamental parts must have been added to the figure-sarcophagi subsequently, or else be attributable to restoration. The improbability of such an assertion is at once obvious.

To what extent the Ravenna sarcophagi were prepared for certain persons and for erection in certain places is naturally of the greatest importance for the problem of the stylistic relationship between these works and the art of the East. Some investigators, Wulff, for example, believe that most of these sar-cophagi were imported from eastern workshops situated either in Proconne-sus, or in Asia Minor, Antioch or Palestine. The marble does certainly appear to be of Greek origin and it has been proved that during the Byzantine period ready-made architectural component parts were exported from the marble quarries in Proconnesus. The resemblance of certain sarcophagi to some fragments which have been preserved in the East leaves no room for doubt as to the existence of this relationship, but the fact that we only meet with "Ra-

venna" sarcophagi in Ravenna itself or in the neighbouring districts, but never, for example, in Rome, gives us cause for hesitation. It is also impossible to establish any relationship between the sarcophagi and the other architectural parts which were imported, while, in addition to this, the dissimilar and frequently incomplete decoration renders the hypothesis of an importation of sarcophagi rather unlikely. Finally, we know from an edict of King Theoderic, issued in consequence of the growing tendency towards excessive luxury in the matter of sarcophagi, that there existed in Ravenna a workshop belonging to a privileged Master Daniel. This Daniel, on account of his Old Testament name, has been held to be an Armenian, or at all events an Oriental. In any case the edict of King Theoderic helps to give us an idea of what we may fairly suppose to have been the constitution of these Ravenna workshops. We must bear in mind that the various rulers, in case of necessity, may either have placed their orders abroad or else have summoned artists and workpeople to Ravenna for the purpose of establishing workshops; for we know for certain that Theoderic caused artisans who specialized in a particular branch of marble-carving to be brought from Rome to Ravenna. This importation of foreign artists, which varied according to the changes of rulers or of fashion, might very well explain the presence in Ravenna of the most varied stylistic tendencies, and this would open up incalculable possibilities as regards the formation and mixing of styles. It would perhaps be as well to mention at this point, that the ivory throne, which it is no longer possible to doubt was made for the Archbishop Maximinian (545-556), since Gerola has proved the existence of the same monogram on a fragment of an impost in Ravenna, is an example of the transference of a masterpiece of carving in the oriental style to Ravenna. We are inclined to think that the stylistic origin of this work must be sought in Alexandria, to which city many investigators, from Gräven down to Baldwin Smith, have endeavoured to assign it, although Strzygowski assumes that it originated in Antioch or the surrounding district. In this case it would be very interesting to ascertain whether the Archbishop Maximinian — to whose order the Berlin diptych may also have been carved — ordered the throne to be sent from Alexandria, or whether he brought ivory-carvers to Ravenna, where Stuhlfauth assumes the existence of a school to which many similar works might be attributed.

The most important specimens of early Ravenna sarcophagus-sculpture are

two sarcophagi preserved in San Francesco, one of which, nowadays used as *Plate 29* high altar, was formerly the tomb of Bishop Liberius (II?, died 351), while the other was only brought to the church in the year 1881. These two sarcophagi form a group by themselves in the classification of Ravenna sarcophagi, but notwithstanding this they are very different from each other. The Liberius sarcophagus is decorated on all four sides, the long sides being divided by arcades with twisted pillars, the tympanum of each arcade being filled with a scallop. Under these arcades stand the Apostles, and in the middle is Christ enthroned, proclaiming the Law. The style betrays an astonishing similarity to that of Greek models. It is scarcely possible that this style can have arisen in Ravenna, and this is one of the cases which give credence to the supposition that this workshop must have been a branch of one from the Eastern Roman empire; we might even assume that these two sarcophagi are isolated examples of the importation of sarcophagi from the East. The second of the two sarcophagi is ornamented on three sides only and the style of the figures is rather heavier, a fact which has induced a number of investigators to suppose that there must be a considerable interval of time between the two works, although there is disagreement as to which of the two is the older. The scallops filling in the arches of the arcades on these sarcophagi, which we have mentioned above, possess a curious feature, namely, that the scallop is always turned upwards. Weigand has demonstrated that this is a peculiarity of Eastern art, whereas Roman and western sarcophagi in general only present scallops turned downwards. This *motif* is not found on other figure-sarcophagi in Ravenna; but at this point we must draw attention to another work in which the scallop-filling in the tympana of arcades is used to a particularly large extent. We refer to the four marble columns which support the ciborium of the high altar in St. Mark's at Venice, each of which is encircled by nine rows of arcading, in which are depicted biblical stories from the Old and New Testaments, containing many details drawn from the Apocrypha. On the walls of St. Mark's there are also several remains of a similar monument (strips of relief and single figures). The pillars of the ciborium, which in fact are works of exceptional importance, have been the cause of many difficulties to art historians. It was a long time before the certainty of their Early Christian origin was admitted, and before the contemporaneity of the rear pillars, which were executed by a weaker hand, was recognized, thanks chiefly

to the investigations of Von der Gabelentz. As to the origin of these columns nothing certain is known. Iconographic and stylistic relationship with eastern art is evident. For this reason many have sought to attribute them to an Antioch or Palestine workshop, while formerly Ravenna was suggested. In the richness of their narrative content they far exceed anything which sarcophagus-sculpture can offer.

As we have already mentioned, the type of arcaded figure-sarcophagus is not found again in Ravenna, and although attempts have been made to relate the group of the Liberius sarcophagi to one now in Santa Maria in Porto which was used in the twelfth century for the burial of Pietro degli Onesti, the similarity in this case is limited to the elegant and lightly-carved figures, an obvious survival of the antique. The arrangement of the decoration on this sarcophagus is typical of Ravenna. The front is framed in by small twisted angle columns and closed at the top by a Doric cyma. The figures are distributed in such a way that broad stretches of background appear. The representation consists of that favourite theme of Ravenna sarcophagus-sculptors, the so-called *Traditio legis* and is continued on the ends by pairs of Apostles carrying wreaths, while the back contains a simple symbolical representation consisting of a cross between two doves with a palm on either side. Very similar to the sarcophagus of Pietro degli Onesti in the choice of subject, in the low framing of the spaces reserved for the reliefs and in the distribution of the figures, are

Plate 32 two certainly much more recent sarcophagi in Sant'Apollinare in Classe and in the cathedral at Ferrara. The carving of the figures in these two monuments, however, has completely lost the easy elegance that is so striking on the Liberius sarcophagus; on the contrary, the figures are broad and heavy, the arrangement of the draperies is simpler, and there is an obvious effort to give more life to the figures by violent gesticulation and movement. It has rightly been remarked that these reliefs are closely connected with a fragment in the Kaiser Friedrich Museum in Berlin which came from Synope, which means that this stage in stylistic development is also a proof of the close relationship existing between the workshops of Ravenna and the East.

The above sarcophagi may also be related to a whole series of magnificent and iconographically very important sarcophagi. We refer to the sarcophagus subsequently used for the burial of St. Rinaldo (*ob.* 1321), the sarcopha-

Plates 30, 31 gus of the Pignatta family (also called the sarcophagus of the prophet Elisha)

28

in the Braccioforte chapel in the square in front of San Francesco, a sarcophagus and a fragment in the museum, and finally the sarcophagus of the Exarch Isaac (*ob.* ca. 643) in San Vitale. The Isaac sarcophagus has played a prominent part in the discussion as to the dating, but as the lid, the inscription on which refers to the exarch, was obviously added later, the date of his death can only represent a *terminus ante quem*. All these sarcophagi have one feature in common, namely, that their figure-decoration, which, as is always the case, is enclosed within an architectonic framework, is restricted to a few figures. Palms are frequently employed in the composition, and on the Rinaldo sarcophagus strips of cloud fill in the empty stretches of sky. The manner in which these lightly-sketched clouds seem to melt into the sky inevitably gives rise to the question as to the role of painting in the decoration of such monuments. The figures have in every case a certain heaviness and squatness which, combined with the energy of movement, produces a curious effect which has always, however, a certain dignity. The best of these sarcophagi is perhaps that of the Pignatta family, although its chief subject, Christ enthroned with his feet resting on lions and dragons, and the chief Apostles and palms on either side, has been spoilt by exposure to the weather, as is the case with most of these sarcophagi. The side panels, on which are represented the Annunciation and a meeting between two figures (perhaps Joseph and the Virgin, but the interpretation is not certain), are in strong relief and the impressive simplicity of the draperies and clear vivacity of the outlines prove that sculpture had not lost the art of monumental creation. If we could only trace the preliminary stages of the monumental sculpture which appears in Northumberland in so mysterious a manner about the year 700, it might be possible to establish a definite connection, even though we know nothing of the intermediary stages, which must undoubtedly be sought in the East. The Isaac sarcophagus with its clumsy, rather empty and schematized Adoration of the Magi on the front, produces the least effect. Still more defective is the design of the figures on the Exuperantius and Barbatianus sarcophagi, in which by way of exception the few figures are arranged under arcades and the decorative element prevails.

We thus come to the question of the ornamental element in the decoration of sarcophagi, of which we have hitherto omitted to speak, in order first to give a clearer exposition of the development of the figurative element. Although

the Ravenna sarcophagi are generally decorated after the Greek manner on all four sides, the fourth is usually given scant attention, and may even be left entirely without ornamentation. The only exception to this is the Liberius sarcophagus on which both the long sides bear representations of equal importance. In other cases, even on the most sumptuous sarcophagi, the back is generally decorated with purely symbolical ornamentation, as is also frequently the case with the ends. We thus find, in various stages, an uninterrupted chain of relationships between the figurative and the purely ornamental sarcophagi. It is impossible to distinguish these two groups from the point of view of dates. It we wish for yet another proof of the close relationship between figure and ornamental sarcophagi, it will suffice to mention that the ends of the lids of

Plate 33 the Theodore sarcophagus (Dütschke 79) are almost identical with the sarcophagus with the representation of Christ and the twelve Apostles in Sant'Apollinare in Classe (Dütschke 80). Both sarcophagi belong, as regards date and place of origin, to the same group, as Dütschke has rightly observed.

The sarcophagi bearing symbolical and ornamental representations are thus connected with the figure-sarcophagi in the general arrangement of the ornamentation. The only exception is the Constantius sarcophagus, on the front of which the architectural framework is lacking, being replaced by a profile border such as is found on choir-screen panels. The subject represented on the front of the Constantius sarcophagus is a rendering in symbolical form, by means of lambs and palms in the midst of a paradisiacal landscape, of the same ideas as are found on the figure-sarcophagus of the Pignatta family. The Honorius sarcophagus is decorated with a rich assortment of architectural *motifs*. In a whole series of sarcophagi in Sant'Apollinare in Classe the coexistence of the different types with or without architectural *motifs* may be studied. In large figure-sarcophagi we often note a tendency to reserve the whole of the back for a large group of animals, for example the peacocks on either side of the monogram of Christ on the Rinaldo sarcophagus, the fat-tailed

Plate 31 lambs on the Barbatianus sarcophagus and the two deer with a vase on that of the Pignatta family. Similarly on the sarcophagi without figures the representation of lambs and peacocks is frequently repeated on the front and amplified by the addition of trees or foliage. The most elaborate example of this

Plate 34 kind is the sarcophagus later used for the burial of Archbishop Theodore (*ob.* 691), in which animals amidst vine tendrils are predominant in the decora-

tion; we shall return shortly to the further consideration of this feature. The front of the same monument presents once more the *motif* of the Christian monogram between two peacocks, near which are two vines with birds pecking at the grapes. The back shows vine tendrils with leaves and grapes and on either side of a cross all kinds of animals feeding. The ends (one of them incomplete) display a cross and vase and foliage with quatrefoil, lily-like blossoms, in which the doves are again to be found.

The solution of the problem regarding the dating of the end of the flourishing period of sarcophagus-sculpture in Ravenna has not yet been attained; if we take the lid of the Isaac sarcophagus as a basis, it must have been long before the middle of the seventh century. In any case, such sarcophagi which authentic inscriptions prove to date from the eighth century are nothing but rough imitations of older types. This also agrees with what we have already seen to have taken place in other branches of sculptural activity. Unfortunately, of the stucco decoration which, according to our sources of information must have played a very important part in the decoration of the churches in Ravenna, we possess only a few remains. Moreover, in the Battisterio degli Ortodossi, where the stucco decoration had been completely preserved, *Plate 28* a considerable part of it was destroyed about fifty years ago, because it was erroneously held to a be later addition without any artistic value. In consequence of this, the reliefs in the tympana of the arcades in particular, with their symbolical ornamentation, have been lost; they contained representations such as we find on sarcophagi. The only remnant which has been preserved is the arching of the arcades near the windows in the upper storey, containing figures of prophets (?), and little symbolical scenes above the architectural setting. This part of the stucco decoration has likewise been declared to be a clumsy mediaeval addition. As a matter of fact the architectural setting in which the figures are seen at the present day gives a wrong impression; for they were intended to be placed in an arrangement of perspectively deepened niches, with alternating gable-shaped or arched coverings, similar to those seen in the mosaics placed above them. The architectural connection is, however, very difficult to understand, especially as the indispensable frontal supports of the niches are only very flatly carved, for the reason that they come behind the pillars which support the dome. Unless we are to assume that very considerable disfigurements took place at a later date, it is dif-

31

ficult to explain the present position as due to anything but the most astonishing lack of foresight and ability on the part of the artists, an assumption which the faulty carving of the figures tends to confirm. This fact is even more surprising when we consider that the stucco decoration which Archbishop Ursus, whose name is mentioned in connection with the construction of the Baptistery, caused to be executed in the neighbouring cathedral, was of such unusual importance that Agnellus considered it worthy of a detailed description in which he even mentions the artists by name.

Although in Ravenna we find no sculptural decoration on the façades of churches such as has been preserved in or near Spoleto, the churches of the city, in addition to the capitals, in which the changes in taste from one generation to another may be followed, were richly adorned with marble altars, pulpits, choir-screens, etc. Although, unfortunately, we possess no complete example of such decoration in its original state, yet such remnants as have been preserved serve in many respects to complete our study of sarcophagus-sculpture and enable us to reach important conclusions regarding the changes of style and the relationship to the art of the East. Very little has been left of fifth-century decoration; but in several buildings in Ravenna, for example in Sant'Agata, in San Giovanni Evangelista and in the museum, we find panels which must have belonged to choir-screens of the period, and in their stylistic arrangement resemble those found in Greek churches of the fifth century, as exemplified by Laurent's description of the discoveries in Delphi. The chief decorative *motif* of such panels is generally a wreath encircling a sort of hexagonal monogram with heart-shaped intervening concavities. Long strips run out from the wreath and terminate in heart-shaped leaves supporting a cross. In addition to such panels we also find others which are covered with an abundance of animal and foliated decoration corresponding to that found on certain sarcophagi. A panel of this kind, containing excellent representations of

Plate 37 b turkey-cocks, has been preserved in Sant'Agata, and another showing peacocks in the midst of vine tendrils in Sant'Apollinare Nuovo. These panels are the earliest examples of a kind of decoration which in the following centuries found great favour and was very widespread. In all the works we have hitherto mentioned the comparatively flat relief is characteristic. In complete contrast to them is the balustrade of the pulpit in Sant'Apollinare Nuovo, the decoration of which consists of geometrical compartments and deeply-cut profiles.

32

This corresponds to a different, Byzantine stylistic tendency, which apparently appeared during the sixth century. In contrast more particularly with these sharply-profiled panels is a new style which we meet with in Ravenna in a whole series of marble works produced during the sixth century. This new style is exemplified on most of the capitals and choir-screen panels in the church *Plates 35 a, 38* of San Vitale, which was consecrated in 547 under Archbishop Maximinian. Whereas the older Ravenna churches show a preference for the old-fashioned acanthus capitals, and in fact employ the *acanthuss pinosus* so popular in eastern art, with clear and sharply-outlined drawing of the prickly leaves, in San Vitale we find impost capitals, which signify a complete victory of a new constructive and decorative conception over the principles of antique art. In these capitals, whether they are cubiform, basket, bell-shaped or in- *Plate 38* dented capitals, the decoration is in flat surfaces, but the *motifs* are so deeply cut, and so separated from the nucleus of the capital, that it appears as if filigree work were hung round the capital. The effect obviously relies on the contrast between the light, flatly-modelled surface of the ornamentation and the background thrown into deep shadow. It is very probable that the magnificent examples of this new style which we find on the capitals in San Vitale and on a few in Sant'Apollinare Nuovo were imported ready-made from the marble quarries of Proconnesus. Similar capitals are found not only in various places on the coasts of the Adriatic but also throughout the East from Egypt to Constantinople. The same transformation of style may be seen on the choir-screen panels in San Vitale and the cathedral. These panels are *Plate 35 b* for the most part covered with an endless repetition of interlaces, and in the meshes of this network and the spandrels are all kinds of foliated *motifs* (including the so-called seaweed acanthus) and also birds, crosses, and the like. The background is sawn out. A curious variant of this style is to be seen on two small panels in Sant'Apollinare Nuovo, where vine tendrils and *Plate 36* linear patterns with frequent rectangular interruptions are seen together with scattered symbolical *motifs* on a cut-out background. Here again we find the contrast between the ornamental or figurative representations, deeply-cut but lightly-modelled on the surface, and the shadow of the sawn-out background. There can be absolutely no doubt that this style, which obviously penetrated into Ravenna art shortly before the middle of the sixth century in a complete and finished form, must have been adopted from the East. Both the subjects

33

and the method of treatment are of the greatest importance for the development of style during the succeeding centuries.

A study of the stylistic changes in the forms of vegetal ornamentation in Ravenna sculpture is very instructive. On the sarcophagi two opposing methods are to be discerned, which are never found mixed, but may nevertheless occur close together on the same sarcophagus. One of these consists of the foliage with quatrefoil or lily-like blossoms, the other of vine tendrils and grapes, the latter being the form which from this period onwards becomes more and more frequent. Although vine tendrils were common in Roman art, the particular form which we are now considering, with its constantly increasing tendency towards stylization, is a phenomenon which originated on the eastern shores of the Mediterranean; its peregrinations have been followed step by step by Brœndsted down to the point at which it develops into the sculpture of northern England. It is worthy of note that this vine ornamentation appears in Ravenna in a great variety of forms; the leaves are sometimes more realistic, sometimes imitated from the prickly acanthus; and in the same way the grapes may be either realistically represented, for example, in the form of Turkish grapes, or else strictly stylized. The small, open-work choir-screen panel in Sant'Apollinare Nuovo mentioned above, may be compared with the decoration of the Antioch pillars in front of St. Mark's at Venice, while the arid nature of a strip of relief found in the same church bears a strong resemblance to the pillars found in Saqqara.

Thus Ravenna, at the period when Justinian was encouraging with all the means at his disposal the architectural activities of the recently re-conquered city, shows itself to have been a reservoir which relied mainly upon the art of the East; but this source of supply only lasted a short time. On the contrary we are impressed by the fact that the artistic influences which favourable circumstances had assembled in Ravenna soon vanished from the scene. Even in *Plate 37a* San Vitale the alabaster slabs of the high altar, which was for a long time in the Mausoleum of Galla Placidia, show a lamentable decline from the strength and elegance of the new style mentioned above. On this altar are represented two lambs, scarcely recognizable as such, on either side of a cross, a *motif* frequently found on sarcophagi. The same clumsy and weak representations *Plate 38* of animals are to be found on the imposts above the capitals in San Vitale. To these works may be related a number of pulpits, in which the breastwork

34

is divided by a framework into small compartments, each of which contains a representation of animals. This is the case with the pulpit of Archbishop *Plate 39* Agnellus (556-569) in the cathedral and with that which Primicerius Adeodatus presented to the church of SS. Giovanni e Paolo in 596. A similar fragment is to be found in Santo Stefano at Bologna. Even on the Agnellus pulpit the animal figures are cut out like silhouettes, and on the Adeodatus pulpit they are coarsely stylized. If these pulpits are to be considered as fair samples by which the artistic capability of Ravenna workshops from the middle of the sixth century is to be measured, it is evident that the decline in style set in with unusual rapidity. As an example of sarcophagus-sculpture which corresponds to this stage of stylistic development, we may mention the rem- *Plate 40 a* nants of the St. Ecclesius sarcophagus in San Vitale. The eighth-century sarcophagi with their scanty decoration represent the last survivals of this art. *Plate 40 b* The same rapid decline of style may be noticed in monuments belonging to the region which came under the influence of the art of Ravenna, as, for instance, the breastwork of a pulpit from Voghenza, now in Ferrara, which it *Plate 52* is impossible to date with precision; this work is nothing but a poor imitation of the old decoration with peacocks and vine tendrils. That this low standard of art had already been reached by the end of the seventh century is proved by the pulpit in the church of the Misericordia at Ancona, which dates from the time of a Pope Sergius who cannot be other than the first of this name (687-701). In its principal *motifs* the latter work is connected with a pulpit-breastwork in Santo Spirito at Ravenna, but the conception of form is terribly crude; the increasing popularity of strips of interlaces to be noticed on this pulpit and on the late sarcophagi is a reminder of the Lombard style, the formation of which began about this time and of which we shall speak later.

IV

ROME DURING THE OSTROGOTH AND BYZANTINE DOMINATION

THE development of sculpture in Ravenna, of which we have attempted to give an exposition, is in direct contrast with that of Rome, so far as we have followed the latter hitherto. "Roma ne fu immune", Rome and the other regions of western Italy were unaffected by the vogue of ornamental and symbolical decoration as seen on sarcophagi and choir-screens in Ravenna; with this catchword Father Raffaele Garrucci imagined that he had characterized this contrast. The reality, however, seems to us to be, that from a certain moment, which has yet to be established, in the course of the fifth century, even Rome was compelled to renounce its own individual style and to succumb to the new ideas which came from the East. As a matter of fact, this transformation took place before the generals of Byzantium had reconquered Rome and Italy and re-united them to the Eastern Empire, before the devastations resulting from the wars waged against the Goths had put an abrupt stop to all development, and before the newly-instituted Byzantine government and the Greek churches and monasteries which were founded in Rome and elsewhere had had time to exert any decisive influence. If we consider for a moment the Roman ivory-carving, which we have already followed in a continuous line of development down to the Boethius diptych, we notice that the native traditions appear more vigorous down to this time, although Delbrueck and Capps claim to have observed a strong Alexandrian influence as early as the last thirty years of the fifth century (starting from about the time of the Emperor Anthemius, 467-472). It is not until about the year 500 that the Roman tradition gives way to an imitation of Eastern Roman models. In the sixth century the Western Roman diptychs seem to be mere copies of

Plate 41 Eastern Roman models. This is the case with the Orestes diptych (530), which is copied from that of Clementinus. Similar observations may be made in the realm of ecclesiastical marble sculpture, so far as the rather scarce material at our disposal enables us to form an opinion. From the old church of San Cle-

Plate 42 mente there have been preserved a few remains of the ciborium and the choir-screens, which were executed to the order of the presbyter Mercurius who

36

later became pope under the name of John II (533-535). Most of these panels are closely related to the earliest stage of the style which we have seen prevailing in Ravenna, and show the same preference for wreath and cross *motifs*, but side by side with these we also find panels decorated with closely-woven basket tracery which on the one hand must be compared with those in San Vitale and on the other hand are the nearest approach which we possess to the monuments found at Saqqara. The capitals, some of which appear to have been brought to Lyons cathedral in the nineteenth century, also resemble the style which appears for the first time in San Vitale. Among the few monuments in this style still existing in Rome may be mentioned as an example of the remains of a secular construction the parapet panels of the Pons Salarius, built by Narses. The sculpture on the pedestals of the pillars supporting the women's galleries in San Lorenzo fuori le mura, dating from the time of Pope Pelagius II (579-590), with its cross and dove *motifs*, shows the same decline of plastic invention that we note in the Ravenna pulpits of the same period. There are few monuments from the seventh century which can be dated with certainty, but there exist in Rome in a number of churches, and particularly coming from the old church of St. Peter, fragments of choir-screen panels which Mazzanti has rightly attributed to this period. They all have the rather stiff continuation of the mode of decoration consisting of geometrical patterns carved in low relief. No characteristics can be found in them which show any tendency towards a revival of style. The impression that we receive from these monuments is that Rome during the period of the Greek popes played an inconspicuous part in the development of sculpture, a part which cannot be compared with that played by the mural paintings of the period preserved in the church of Santa Maria Antiqua.

V

LOMBARD ART

WHETHER we consider the art of Rome or that of Ravenna, Italian sculpture soon after the middle of the sixth century seems to enter upon a period of decline. Everywhere we find a rapid transition towards the age of "barbarian" art. Cattaneo, speaking of this period, has used the very apt simile of an oil-lamp, which during the Justinian period was kept burning by the addition of a few drops of oil but was soon to be definitely extinguished. To understand this period properly, it is necessary to have a clear idea of the terrible devastation which resulted from the great struggle between the Goths and the Byzantines. For the latter it was a Pyrrhic victory, for only a few years later the Lombards established their supremacy in Italy and brought the whole peninsula under their sway with the exception of Sicily, some strips of coastal territory and a few cities such as Naples, Rome and Ravenna.

Cattaneo has given to the art of this period the name of Byzantine-barbarian art. In this way he has included the two most conspicuous contrasts in the formation of its style. In reality, however, we must remember that stylistic development was determined not only by the Byzantine or Lombard conquerors, to whom later were added the Franks and the Arabs, but in addition to these and more especially in the cities, by the not inconsiderable native population. We must endeavour to distinguish very carefully the share of each of these elements in the development of art, down to the period in which a uniform style was attained.

The introducers of "barbarian" art into Italy were first of all the Ostrogoths, and after them the Lombards. From the investigations of Nils Åberg we learn that each of these peoples brought its own peculiar form of art to Italy, though it must be admitted that in both cases it was mainly a matter of industrial art. The art of the Ostrogoths, who came from the Black Sea, has its origins in the East, while that of the Lombards, who descended into Italy via Pannonia, is essentially of northern origin. The chief sources of our knowledge of the art of both peoples are the material found in tombs; and these finds demonstrate, according to Åberg, on the one hand that hardly any relationship between Ostrogoth and Lombard art was established in Italy, and on the other

that the native population retained its own art and culture long after the invasions, so that the fusion proceeded very slowly and was never completed.

We shall thus find that the penetration of Germanic influences was at first very gradual in every branch of art which was influenced by Roman or Byzantine tradition. Nevertheless one example must be mentioned which seems to contradict this theory: the tomb of King Theoderic at Ravenna which contains amidst its ornamentation the much discussed so-called tenail *motif* or triangle surmounted by a disc on the cornices, a *motif* so closely related to the finds in Germanic tombs and so far removed from anything in late antique or oriental architecture, that we are compelled to assume that Germanic influence was responsible for it. But the occurrence of this feature, the importance of which is enhanced by its rarity, is limited to this one case. As a rule, sculpture during the Ostrogoth period follows the traditions of late antique and Eastern Roman art.

If we seek enlightenment from the coinage of the period, in many respects an excellent source of information regarding the official art of the rulers, we find magnificent specimens of minting in the reigns of the Ostrogoth kings Theoderic and Theodahad. On the other hand, under the Lombard rulers we see, as Wroth has pointed out, the disastrous influence which the Lombards exercised in the field of artistic production. The coins minted during the first years of Lombard rule are merely barbarian imitations of Eastern Roman models, and even later the minting is very rough and the draughtsmanship leaves much to be desired. The same observations may also be made of Lombard helmets. Very characteristic in this connection is the frontlet of gilded copper in the Bargello at Florence, on which is depicted King Agilulf (591- *Plate 43* 615) amidst his warriors, with two winged victories leading up figures to do homage to the king. Although the Lombard figures show evident traces of a tendency towards realism, the relief is nevertheless quite in accordance with antique tradition and only the rather shapeless vigour of the representation seems to suggest the hand of an artist of Lombard origin.

To the time of King Agilulf and Queen Theodolinda also belong two marble plaques on the façade of the cathedral at Monza. Their simple symbolical decoration, consisting of the cross between two lambs and the monogram of Christ in a circle between two crosses, is akin to the style we have already met with in Ravenna. There are no traces on these plaques of Lombard characteristics, and even a peculiarity of technique, the use of small discoid depressions,

39

recalling the stippled goldsmiths' work of the period, may also be found in several works of marble sculpture dating from this period.

The region subjected to the Lombards, like Rome and Ravenna, is remarkably poor in sculptural monuments during the seventh century. It is not until the end of the century that we find works of sculpture showing a new style in full course of development, although it is true that when they do occur, they are found in very large numbers. The greater part of these works — and the same may be said of all similar productions down to the eleventh century — consists of marble objects for the interior decoration of churches, such as re-tables, canopies, choir-screens, episcopal thrones, pulpits, window-fillings and font-covers. As far as architecture itself is concerned, only the capitals have to be considered, as no portal sculpture of any importance can be found before the end of this period. Sculptured sarcophagi are rare and secular works are seldom found. The function of marble or stone sculpture is mainly decorative. The sculptors of the period cover the surfaces with ornamentation which in part has a symbolical significance, but "representations" in the true sense of the term are very exceptional. The predominantly ornamental character of this enormous mass of monuments might be considered evidence of the movement for the suppression of all figure-representations, which was current at that time in all the regions subject to the Byzantines and is by some supposed to have been the cause of a decline of figure, as opposed to ornamental, sculpture. We must be extremely cautious in accepting this theory, for we must remember that even during the preceding period the ornamental treatment tended to gain the upper hand in similar works, while documentary sources of the period prove that the churches at that time possessed a large number of sculptured figure-monuments. This is certainly true of Rome, where the "Papal Book", a document of inestimable value for the study of this period, gives very precise information. It almost seems as if during the period of the iconoclastic controversy this form of sculpture enjoyed special favour in Rome, and we have documentary evidence that in other parts of Italy, for example, in Grado, sculptural decoration of this kind was likewise commonly found in churches. These works were, however, for the most part in metal, and especially in precious metals. It is difficult to determine whether they were sculptured in the round or in relief. It is, however, certain that the altars in particular and the ciboria were richly decorated with figures. Chroniclers of

40

the time have considered these works in metal worthy of detailed description, partly on account of their high intrinsic value and partly on account of the subjects depicted upon them; the decoration of the churches with costly fabrics is also described in detail, while for reasons which it is easy to understand the mainly ornamental marble sculpture receives less attention. In addition to the works in metal those in stucco are occasionally mentioned separately. Such works as have been preserved prove that the tasks of the artists who worked this all too perishable material were quite different from those of sculptors in marble. The monuments preserved at the present day thus give us only a partial idea of the art of the period. The larger monuments in metal have disappeared completely and the small objects preserved cannot possibly provide an efficient substitute. As for the few monuments in stucco which have been preserved, the tendency of modern research has been to neglect them, because they do not fit in with the general scheme of development which may be seen in the works in marble. In this way our already scanty notions of the period have been still further impoverished.

It would be difficult to find a branch of the history of mediaeval art which has been the subject of such detailed investigation and at the same time has given rise to such a number of fundamentally different attempts to explain the peculiarities of style, as is the case with the sculpture of this period. If we classify the attempts to discover the derivation of artistic style during the Lombard period, the following main tendencies are found:

1) Derivation from the style of Etruscan or Roman art, or from the provincial art of the late antique period.
2) Derivation from Byzantium.
3) Derivation from the East, especially from Syria, or from Coptic art.
4) Derivation from the art of the Germanic north.
5) Derivation from Frankish art as a result of the Frankish conquest.
6) Derivation from Irish art as a result of the Irish missions.

From this short résumé, which is only intended to indicate the main lines followed by investigators, we see that Lombard art is brought into relation with practically every artistic movement from Ireland down to Egypt. The possibility of such a manifold derivation is based partly on the ornamental character of Lombard sculpture, which makes it easier to find resemblances.

41

It is also due, however, to the sharp contrasts to be found among the monuments of the Lombard period, in consequence of which the different investigators, according to the definite period or the group of monuments which formed the object of their studies, incline towards one or another of the above-mentioned theories as to the derivation of this art.

If we attempt to reduce these theories to a simple formula and to concentrate them according to their main directions, the following chief sources result: late antique, Byzantine-oriental and barbarian. These correspond on the whole to the political and ethnographical factors as presented by the native population and the Greek and Lombard conquerors. But while it is not exactly easy to define clearly the limits of the late antique and Byzantine-oriental influences, the problem is even more difficult when we come to the influence of barbarian art. For when we speak of barbarian art, we do not only think of the particular and original art which the barbarians brought with them, or of the transformation or barbarization of the art which they found, but we also assign to the term "barbarian" a qualitative value which only defines the quality of this art and not its essential characteristics. This conception opens wide the door to all kinds of misunderstandings.

The question naturally arises whether the barbarians were really the first who by their want of artistic culture and manual skill were responsible for such a decline in art. Similar phenomena during the period of antique art have also formed the subject of discussion, for example the Tropaeum Traiani at Adamklissi, the sculptures of which have been summarily described as clumsy and bungled work. In many places in the provinces of the Roman Empire we also find monuments lacking in style, some of which are mere caricatures of the antique models. To what extent the peoples who had been established for long periods in such regions and had escaped both the Hellenistic and the Roman influences are to be held responsible for such works is a problem which needs careful examination.

It is, however, a fact that when mediaeval art does not derive from the lofty traditions of the great centres of culture but from the local activities of stonemasons, we only find correspondingly inferior achievements. In unsettled times, such as the sixth and seventh centuries undoubtedly were for Italy, the artistic inheritance was naturally exposed to great danger; and what hope of resumption or restoration of art could there be when even in the East the icono-

clastic controversy threatened the very foundations of plastic art? It is highly significant that even in Ravenna the same decline can be noted in the monuments which do not bear the stamp of the style peculiar to the Lombards, such as, for example, the Felix sarcophagus. In every region except those in which foreign help was called in, or where the example of foreign artists was a spur to emulation, the marble sculptors during the period in question lose the art of depicting correctly a human figure or an animal. That the art of modelling and of deep cutting appears to be unknown to these artists is not surprising, for the tendency towards shallow cutting became a principle of art during the time of Justinian; but we should be paying these marble sculptors too great a compliment if we were to consider them as anything more than modest stone-masons who were completely estranged from the monumental sculpture of their time, which had little to do with decorative carving. It is therefore not surprising that the abundance of ornamental works to be found both in the East and in the West at the close of the antique period gradually declines. It is as if the tree of ornamentation shed its finer but withered blooms and replaced them by rougher and simpler formations which were perhaps more in accordance with the spirit of the people. The simpler these formations, the more difficult it becomes to say whether their origin is to be sought in the inborn artistic talent of the people, or whether they were brought from a distance, and particularly from the East.

If we wish to outline the historical course of this development, at the very beginning we are brought face to face with the fact that the monuments dating from about the year 700 possess a style which is lacking in national characteristics and is clearly of Byzantine-oriental origin. This style, however, corresponds only in part to the Ravenna style of the sixth and seventh centuries; an evident transformation has been effected which is to be ascribed to a current of new, and until that time unfamiliar, oriental elements. The most notable feature in this new style is the sudden appearance of an oriental animal ornamentation; which, with its sharply-outlined animal forms, is not only in obvious contrast to the animal ornamentation of northern countries with its very unnatural and obscure forms, but also to the more naturalistic representations of animals such as are so frequently found in the art of Ravenna. In place of tame animals like the deer, the lamb and the dove, we now find wild animals and fabulous creatures, such as the lion, the griffin, the sea-serpent

43

and the eagle. They are often found in pairs, either facing, or with their backs turned to each other, and are represented on either side of a vase or of a tree.

How did this eastern conception of the animal world penetrate into western art? If we open the Papal Book, we find everywhere mention of stuffs, often called Alexandrian, on which representations of animals were worked. The West must have been flooded with such productions. Their transformation into stone reliefs, which also occurs in the Byzantine and Hispano-Arabic zones of art, was a natural consequence. It is a curious fact that we do not yet find this style appearing in the artistic productions of the Ravenna school which we have already studied above (the little sarcophagus at Ravenna, on which is represented a lion — Dütschke No. 38 — does not belong to this period). The material preserved is, on the whole, scarce and it is impossible to trace step by step the development of models and imitations. Such examples as have been left in the regions invaded by the Byzantines are in part later than the oldest Lombard imitations.

Plate 44 As a starting-point of our study of this movement, we propose to take the monuments of the Lombard capitals. The sarcophagus of Theodota (who died in 720) in the museum at Pavia is particularly suited to give an idea of the changes wrought by time and by contact with oriental art. The front of this sarcophagus consists of a broad tracery of foliage in which rosettes alternate with vine-leaves and grapes. The middle panel shows a tree between two winged sea-serpents, and this tree brings forth heads of animals in addition to the usual vine-leaves and grapes. Compared with the Early Christian art of Rome and Ravenna, this sarcophagus is a complete novelty. The connection with eastern models is unmistakable. Heiberg and Brœndsted have even assumed that it is the work of an eastern artist, a question to which we shall return very shortly in connection with another matter. A number of other works of a similar nature may be brought into relationship with the Theodota sarcophagus. In the first place, it has been likened to the tombstone of the holy bishop Cumian, a native of Scotland, in Bobbio, on account of the similarity of the decoration on the borders. The inscription on the tombstone mentions that it was produced during the reign of King Luitprand (721-744); the end of the inscription is as follows: Magister Johannes fecit. If this Johannes was the sculptor and not merely the author of the inscription — we know nothing further about him than what is revealed by this inscription — his

44

un-Lombard name fits in very well with the Byzantine-oriental tendencies of his style. Curiously enough, the inscription is also placed upside down on the ornamental framework. Whether we accept Toesca's theory or not that this tombstone had already been prepared before the death of the bishop, we must at all events agree with Cecchelli in attributing it to an oversight. The form of these sepulchral slabs seems to have been typical of those produced during a considerable period, for that of St. Vitalianus at Osimo, which cannot be earlier than the latter part of the eighth century, is very similar.

Kingsley Porter, like his predecessor Margaret Stokes, claims to see in the above-mentioned three tombstones the work of Magister Johannes, whom he believes to have been the holder of a monopoly for the supply of official tombstones to the Lombard sovereigns, as the sculptor Daniel was to the Ostrogoth court at Ravenna. We may leave aside this supposition, which in any case is not applicable to the much more recent and poorly-stylized slab in Osimo, but we must first deal with another statement by Kingsley Porter, namely, the assertion, to which he was led by observation of the fact that the back of the sepulchral slab of St. Cumian is covered with a large interlace, that this ornamentation must be considered as contemporary with the inscription and consequently that, taking into account the Scottish origin of St. Cumian, who entered the monastery founded by the Irish abbot Columbanus at a very advanced age, the representation in stone of interlaces must have been brought to Italy by Irish monks. In this way one of the most prominent features of the so-called Lombard style would be ascribed to Irish influence. A necessary condition to the acceptance of this theory would, however, be the contemporaneity of the decoration on the front and back of the tombstone, and Toesca is doubtful as to this point, for he speaks of the possibility of dating the back from the eighth or ninth century. We are inclined to agree with him in this, for we can see no resemblance between the front and back ornamentation. Even if everything coincided with Kingsley Porter's theory, quite different conclusions might be drawn therefrom, for the four successors of Columbanus were Franks, and in this manner we might very well arrive at the same conclusion as De Lasteyrie, namely, that this style was derived from Frankish models.

In any case, such attempts to trace the derivation are neither necessary nor pertinent, for the appearance of interlaces in Italian sculpture may be traced

45

back to the fifth century, as, for example, on the fragments of pillars from San Salvatore at Spoleto and in numerous cases in Roman and Ravenna sculptures of the sixth century. The interlaced quadrilaterals of the Bobbio tombstone have forerunners on the choir-screen panels in Ravenna cathedral and parallels to them may be found in later Byzantine art; in Bobbio, however, they appear in a form which is not found elsewhere until the latter part of the eighth century.

The style of the Theodota sarcophagus was, as the above-cited examples demonstrate, not limited to Pavia. Closely related to it are the sculptural fragments, now preserved in the cathedral museum at Modena, the date of which must be in the lifetime of Lopicenus, who was bishop about the year 750. Specially noteworthy among these is the principal fragment, a very long transom panel on which is represented a cross between lions, peacocks and stags grouped in twos, and surrounded by rich ornamental borders. Byzantine-oriental *motifs* predominate here also. The richest group of monuments from this period is, however, preserved in Cividale, which was the residence of Lombard dukes and of the patriarchs of Aquileia, but it is precisely in these monuments that we have to recognize that the Theodota sarcophagus was typical of only one stylistic tendency of the period, and that at the same time many other very different styles were flourishing. The internal differences between the various monuments to be found in Friuli have been set forth by Cecchelli as a result of the thorough examination he has made of them. For the purposes of our study only the most important of these monuments need be considered. The oldest monuments to which a date can be assigned are connected with the Patriarch Callistus (before 733 to 762) and with the dukes Pemmo (who lived to about 737) and Ratchis (who became king in 744). As regards time these monuments are thus very close to those executed for King Luitprand (712-744).

The patriarch Callistus was the builder of the baptistery whence comes the tabernacle placed over the font, the remains of which have been re-erected in the cathedral. Of this work seven out of the eight archivolts of the octagon have been preserved. The ornamental framework comprises spandrels with animal decoration, in which lions, griffins and sea-monsters are represented in addition to peacocks and deer. Both the ornamentation and the representation of animals are clear proofs of the oriental stylistic tendency. If we exa-

46

mine the details, we find that there is a great affinity to the reliefs in Modena dating from the time of Bishop Lopicenus.

Very remarkable is the contrast in style between the sculptural decoration of this tabernacle and that of the altar, which Ratchis, according to the almost unintelligible inscription, apparently caused to be prepared for a church of St. John as the consequence of a donation by Duke Pemmo. On the front of this altar is a representation of Christ in Majesty, while on the ends are depicted the Adoration of the Magi and the Visitation. The relationship to eastern iconography is unmistakable, but the artist has not been able to grasp the significance of the composition or of the single figures. The landscape elements, which must have been contained in the probably painted model, have been transformed into rigidly stylized ornamentation. The human figures lack proportion, the countenances display characteristics which seem to denote an incredible effort to attain expression. The draperies are indicated by hatchwork lines round the bodies. The result is a style showing a marked peculiarity of distortion, which in its turn may be compared with the choir-screen panel, which, according to the inscription, was a present from the patriarch Sigvald (762?-786?) and is nowadays to be found on the font of Callistus. *Plate 45*

Plate 46

The Sigvald panel has often been compared with the Theodota sarcophagus, because it too contains a representation of the tree on which heads of animals are growing. The difference, nevertheless, is enormous. In contrast to the elegant and accomplished style of the sarcophagus we here find curiously disfigured likenesses; to take an example, the four Symbols of the Evangelists are represented in a form which reveals a very curious transformation of style. All four are shown in half-figure, and grasp the Gospel with insect-like arms and legs. The head of the angel of St. Matthew has the characteristic pear-shaped outline such as is found in the head of the Virgin on the altar. The head of the ox seems more like that of a pig, while that of the lion has a fish-like appearance. Zimmermann has drawn attention to the connection between these figures and the types found in Irish and northern English illumination. The question arises whether this resemblance is to be ascribed to the hand of the painter or sculptor, or whether eastern models of a similar nature were responsible for it, as is probably the case with the miniatures. The importance of these problems is emphasized by another mutilated screen-panel on the font. The latter forms a contrast to the Sigvald panel and is an instructive warn- *Plate 47*

47

ing of the danger of drawing conclusions as to the whole artistic development of a period from the examination of individual monuments. The *motifs* of this second panel are so closely related to those of the heads of animals and the symbols of the Evangelists on the Sigvald panel, that it has been considered unlikely that it can have been intended for the same church. Despite the similarity of subject, the style is quite different, and the two symbols of the Evangelists which have been preserved appear quite naturalistic in their stylization when compared with those on the Sigvald panel.

Plates 48-50 These contrasts of style, which may be perceived on both panels, assume a very different aspect if we compare them with the stucco decoration, resulting from an entirely different conception of plastic form, on the so-called Tempietto, that is to say, the church of Santa Maria in Valle at Cividale, which is one of the most discussed artistic works dating from that period. The date of foundation of this little church is unknown. Legends have formed around the building and have made a pious lady named Piltruda, whose tomb appears to have been transported here from a convent in Salto, the founder of the church. The same legend has promoted Piltruda to the dignity of a Queen of the Lombards. As we said above, the date of this stucco decoration is the subject of much discussion among experts. Both on architectural, historical grounds — the cross-vaulting is older than the stucco decoration — and on those of stylistic criticism, many have maintained that the origin of the church belongs to a more recent period, the conjectures varying between the eleventh and thirteenth centuries. These attempts at dating are quite intelligible, for the stucco reliefs cannot be related in any way to the numerous relics of the Lombard period to be found in other parts of Cividale. All that remains is the decoration of the entrance-wall, consisting of the framework of a lunette of the portal and of a window placed above it; near the latter is a strip of wall-decoration on which are represented six large figures of female saints. The derivation of this ornamentation gives less difficulty. The rosette friezes, the palm-leaves and the magnificent grapes and vine-leaves are all current *motifs* in Byzantine oriental art. In this case, however, they are not represented in the usual low relief, but in very high relief, in part standing right out from the background, or encircling the arches in the form of an open-work cornice. The *motif* which attracts most attention is perhaps the complicated interlace round the arch of the window; the same *motif* can be found in the illumination of the north. These

rich and very complicated interlaces such as are found on mural paintings in Bawît nevertheless serve to impress upon us the necessity for caution in the consideration of the possibilities of derivation. The figures, like the ornamentation, are carved in high relief, so that the heads appear to be almost modelled in the round. Although these figures, with the cramped position of the arms and the arrangement of the draperies, produce a rather stiff effect, they may yet be assigned to a fundamentally naturalistic tendency of style, especially when compared with those of the Ratchis altar. More than one scientific investigator has been reminded by these figures of the solemn figures of Byzantine mosaics, such as may be seen in San Vitale at Ravenna or at Rome in the Venantius chapel in San Giovanni in Fonte. The futility of the attempts to establish a relationship between this stucco decoration and Romanesque art has already been demonstrated by Venturi, and Kingsley Porter, who has recently endeavoured to establish a connection with German stucco-work of the twelfth century, is probably right in emphasizing the already-recognized relationship between German and northern Italian art, although the explanation of this relationship lies in the influence exercised upon northern art by northern Italian artists, and it is impossible to accept the theory that the style of the stucco figures in Cividale is derived from Germany. In this connection it is particularly noteworthy that there have been found in Switzerland traces of early stucco decoration, among which are those of the monastery of Disentis in the upper Rhine valley, where fragments of no less than seventy stucco heads, in part life-size, have been found. We shall consider later the important part played by the Swiss monasteries in the relationship between North and South at that period.

Strzygowski in his study entitled "Oriental Italy" has given the right clue to the problem presented by the stucco reliefs in Cividale. He draws attention to the existence in Egypt, Syria and Persia of works in stucco which serve to give an idea of the high degree of technical and stylistic achievement reached by this branch of art, the productions of which have been almostly completely lost. It is true that this does not solve the riddle of the Tempietto, for the examples quoted by Strzygowski are distant resemblances which cannot be brought into close connection with the works in Cividale. We must therefore limit ourselves to the statement of the fact that in Cividale there is found the outcome of an artistic tendency, the origins of which are not yet perfectly known.

While numerous art historians have vigorously combated the dating of the stucco decoration in the Tempietto from the Lombard period, it is clear that their conviction was mainly due to their one-sided conception of the art of the period, a conception the error of which we have already attempted to show. It must be assumed that these stucco-workers possessed an artistic tradition completely different from that prevalent among the ordinary marble sculptors. We do not know to what extent the stucco-workers were in relation with those other artists who were responsible for the monumental works in precious metals. A certain degree of relationship may safely be assumed, and it was certainly a particularly happy idea of Bertaux to seek relationships between the stucco figures in Cividale and the vanished monumental works in metal which were produced at the same time.

We have no precise data as to the church of Santa Maria in Valle. Cecchelli is convinced that the stucco decoration must date from the revival of artistic creation in Cividale, which he endeavours to identify with the flourishing period of spiritual life during the Carolingian era. He consequently assigns these stucco works, and the obviously contemporary mural paintings, to the period during which Cividale was under the rule of the patriarch Paulinus II (about 787-802). However alluring this theory may be, it cannot be said to offer certain proofs; although it is true that a considerably later origin is quite out of the question.

The long series of monuments mentioned above comprises those works in which the Byzantine-oriental style prevails in a more or less pure form. These, however, are not the works which would appear to have the closest connection with the very numerous works of Lombard character produced in the period which followed immediately upon that mentioned. If we wish to seek the preliminary stages of this latter style we must go back to a different series of works. The earliest among these is the ciborium, the date of which is established by a curious inscription, in the church of San Giorgio in Valpolicella. It was the work of a certain Magister Ursus and of his assistants Juvintinus and Juvianus, and dates from the year 712, that is to say from the time of King Luitprand. The remains of the archivolts, preserved for many years in the museum at Verona, have now been restored to the church and re-composed so as to form a ciborium. It is questionable whether this is strictly correct. As more than four archivolts have been preserved, it is permissible to think of a font-

canopy similar to that of Callistus at Cividale. The contrast between the decoration of these archivolts and that of the works we have just discussed is clearly perceptible. Kingsley Porter has attempted to explain the contrast by assuming that we have on the one hand court productions under oriental influence and on the other an art of local and popular character. In any case it is certain that this is the starting-point of a series of monuments, in which Stückelberg professes to see the beginnings of a native Lombard ornamental art. He bases his assumption especially on the *motifs* which are borrowed from the textile industry, for example, the loops, interlaces and network of rope and thongs, and also the crockets, which are among the most popular forms of decoration of the period, and thinks that these *motifs* may have been partly derived from the textile industry and partly transplanted into sculpture by way of the metallurgical crafts; mixed with antique and oriental components, they thus became an essential feature in Lombard art during the ninth and tenth centuries. This theory of Stückelberg has given rise to much discussion. The question of the origin of this ornamentation has been dealt with in a number of studies, among which the work of V. d. Gabelentz on mediaeval Venetian art is worthy of special mention. As a result of all this investigation it appears to be clearly established that a Lombard invention of these *motifs* is out of the question. We have already spoken of the origins of interlaces and of interlaced patterns with infinite repetitions. The ultimate origin of the crockets may be said to be the "wave-patterns" of antique art etc. The *motifs* of Lombard ornamentation thus derive from antique and eastern art. Vitzthum has concentrated his opinion on these matters into the one sentence: "In this art there is not a single element of national origin".

As a matter of fact, we find also in the realm of Christian art in the eastern Mediterranean basin, from Egypt and Syria to Constantinople and Athens, an ornamental sculpture dating from the same centuries, which presents remarkable resemblances to the monuments of Lombard art. The so-called Lombard art, which even in Italy is by no means limited to the regions ruled by the Lombards, is merely a special evolution of the same style, and the nearest approach to it is represented by the monuments of Croatia, which Strzygowski has recently re-assembled, while there exists in France a stylistic tendency so similar that de Lasteyrie was even induced to maintain that Lombard art was brought to Italy by the Frankish invaders. The threads of this rela-

51

tionship may be followed as far as the stone sculpture of England and Ireland. We have already referred to Brœndsted's studies regarding the spread of these tendencies throughout Europe, and we must mention once more at this point Kingsley Porter's theory of an Irish element in this ornamentation.

While it is very easy to enlarge on the subject of such relationships, on the other hand it becomes more and more obvious that in Italy the characteristics are lacking which would be a clear proof of northern origin. In the closely-related Swiss monuments we find, for example, a tendency to insert in the interlaces heads and bodies of animals, which is in accordance with the customs of northern animal ornamentation and is found in national Lombard art as represented by the objects found in tombs; but if on the other hand we consider the nature of interlaces in marble sculpture, we find a tendency towards a harmonious and regular division of the surface, which is in reality completely un-Germanic, or at all events is not a typically Germanic feature. If we look at the problem from this point of view, the solution of the riddle of Lombard art is that Lombard marble ornamentation is not to be considered as the result of the prevalence of a Lombard artistic system, but is merely the form in which northern Italian stone-masons of the Lombard period contrived to adapt themselves to the general artistic tendency which at that period influenced the whole of Europe. In the eighth century the number of monuments showing this style in its full development which can be dated with certainty is small. About the year 800 they become numerous and at the same time this style begins to spread to regions which are outside the Lombard domain in the strict sense of the word. Ravenna, the city in which, as we have shown, the decay of Byzantine style and the tendency towards that of Lombard art dates from the end of the sixth century, possesses an early masterpiece of the new style in

Plate 53 the Ciborium of St. Eleucadius in Sant'Apollinare in Classe, which was erected in the time of Archbishop Valerius (806-810). It is highly probable that the propagation of this style, which may be traced, as we shall shortly see, right down to the south of Italy, was favoured by the wandering tendencies of the stone-masons from the region of the Italian lakes, the so-called Magistri Comacini, who may be met with, during the following centuries, in all parts of Europe. Unfortunately we have not sufficient information to enable us to say to what extent and from what date sculptors of genuine Lombard origin were engaged in the carving of marble. The few signed works which have been

52

preserved invariably bear names which are not specifically Lombard, such as Johannes, Ursus, Stefanus, Juvintinus, Juvianus; and Maffei has long ago made use of the sculptures at San Giorgio in Valpolicella as a proof that the Germanic invaders were not the first to introduce the so-called barbarian style.

VI

THE LOMBARD STYLE IN ROME AND CENTRAL ITALY

IF WE now turn to the monuments of this period existing in Rome and Central Italy, we are unable to establish any separate tendencies of development in opposition to those of northern Italy. The Byzantine-oriental element prevails here also until about the middle of the eighth century. In a series of examples, similarities with northern Italian works may be observed even in the details. For example, in the Forum Romanum there has been discovered among the ruins of the church of Santa Maria Antiqua an arch of a ciborium, which, according to many writers, is connected with the re-decoration of the church carried out by Pope John VII (705-707). This arch contains a scanty decoration consisting of palms and twisted rosettes. The stylization is thin and *Plate 51* stringy, and corresponds to that found on certain choir-screen panels in Santa Maria in Valle at Cividale.

Similar observations may be made as to the monuments found in Umbria. *Plate 54* In the abbey church of Ferentillo have been preserved a few panels on which Duke Hilderich Dagileopa of Spoleto (after 739) and the Magister Ursus are mentioned. The subject of the representation: the master and another figure standing amidst three cross-discs placed on lofty pedestals, is in itself peculiar; the drawing of the figures is incredibly primitive, as is also the manner in which the technique is limited to the surface and relies mainly on scratching. But the ornamentation, consisting of ovoli, foliage and six-foil rose-leaves, leave no doubt as to the close relationship to oriental stylistic tendencies. Some writers, following in the footsteps of De Rossi, have tried to identify this Magister Ursus with the carver of the ciborium at San Giorgio in Valpolicella, although it is impossible to detect any resemblance of style.

The Ursus panel must be considered as a curiosity. What Umbrian artists of the period were really capable of achieving is shown by a panel on the wall *Plate 55* of San Gregorio at Spoleto, which in its *motifs*, as Hoppenstedt has demonstrated, is related to the gable-ends of the Clitumnus temple, and by a ciborium in the church of San Prospero at Perugia. In both these monuments we find the curious helved discs with rosettes, as on the Ursus panel; while vegetal ornamentation is prevalent but interlaces are lacking. In all these works which

occur in the ducal capital or neighbourhood there can be no question of a national Lombard art.

The transition to the typical "Lombard" style of the ninth century must have commenced in Central Italy, as elsewhere, towards the end of the eighth century. In Rome it coincides with the change in the position of the papacy, when the long series of Greeks and Syrians were succeeded on the papal throne by those popes who in alliance with the Frankish kings brought about the fall of the Lombard kingdom.

The number of monuments in Rome itself and in the environs, especially in the country districts lying to the north, is exceptionally large, whereas in Umbria and Tuscany the remains which have been found are few in number and of little importance. Those monuments to which a date can be assigned run from the period of Pope Hadrian I (772-795). The best works were produced during the first half of the ninth century, after which a notable decline set in. Among the numerous monuments we will mention here as a magnificent specimen of work the remains of the choir-screens in Santa Sabina, which date *Plate 60* from the time of Pope Eugene II (824-827). Certain screen-panels in Santa Maria in Trastevere are typical of the rough style of the eighth century. An *Plate 61* unusually elaborate work, remarkable both for its stylistic features and for the inclusion of the Symbols of the Evangelists among its representations, is the altar in Santa Maria del Priorato, which unfortunately cannot be dated with *Plate 59* certainty. Giovenale has compared this altar with the chief portal of Santa Maria in Cosmedin, the work of a certain "Johannes de Venetia", which he assigns to the time of Pope Nicholas I (858-867), and if this date is right, this portal, on the lintel of which the Hand of God appears between lambs and the Symbols of the Evangelists, is a monument of unusual importance.

In general, however, the character of the remarkably numerous sculptures from this period is uniform, despite the fact that they are distributed over a period of time comprising two or three centuries. No important group is to be found, so that it is difficult to determine the exact point of time at which the undated works originated. If the whole of the Roman and Central Italian sculptures of this period were to be brought together before our eyes, the monotony and lack of invention would be very apparent. The artists invariably adhere to well-known *motifs* and special preference is given to large interlaces covering the whole of the panels. Figures are seldom found, and even

55

the traditional symbolic animals, such as doves, peacocks, and stags, are rare and in the later specimens are reproduced in a remarkably formless manner. Figure representations of a religious character such as the fragment in Trasacco depicting the martyrdom of St. Lawrence are found only as isolated instances. This fact lends additional importance to the appearance of occasional secular *Plate 56b* representations, as for example, the relief on the church at Civita Castellana showing a large hunting-scene and bearing an obscure inscription which ap-*Plate 56a* pears to refer to some Lombard duke. In the church of San Saba at Rome there is a fragment of a panel representing a bearded horseman with a falcon. The object of this monument has not yet been explained.

We have already emphasized the fact that this Roman marble sculpture with its monotonous ornamentation and the poverty of its representations must not be taken as typical of the sculptural achievement of the period. It is difficult to form an idea of the great figure-representations in precious metals which were so numerous in the churches of that epoch. We can only cite a *Plates 57, 58* few objects which have been preserved in the treasury of the Sancta Sanctorum, and especially the silver container of the jewelled cross, the inscription on which mentions a Pope Paschal. It can scarcely be doubted that this refers to Pope Paschal I (817-824). In any case, although these silver reliefs are executed in a style which, compared with the productions of the Carolingian period or the Byzantine Renaissance, appears cumbrous and defective, they are nevertheless far removed from the formlessness and flatness of the marble reliefs and are nearer in style to the paintings and mosaics of the period.

VII

SOUTHERN ITALY

COMPARED with the great abundance of monuments which have been pre-
served from this period in northern and central Italy, the southern part of the
peninsula appears like a wilderness, in which the untiring efforts of learned
investigators were necessary before a few scanty remains of the lost artistic life
of this period were brought to light. It is difficult to say whether the number
of monuments in this region was originally very small; or whether special cir-
cumstances are to be held responsible for the almost complete disappearance
of the artistic relics of the time.

The type of the monuments, so far as we are able to form an opinion from
the little that is left, differs considerably from what we possess in northern and
central Italy. From the days of the Lombard conquest the south of Italy be-
longed to the dukedom of Benevento, and Byzantine rule had survived only
in Sicily and in a few coastal regions. In 827 Sicily fell a prey to the Arabs,
who during the ninth century also gained a foothold in Apulia and on the
coast of Campania, threatening to overwhelm Christianity in the whole of
southern Italy. When at the end of the tenth century the power of the Arabs
on the mainland was broken, the Byzantine Empire established in the eastern
and southern parts of Lower Italy a dominion which lasted until the time of
the Normans.

From the point of view of the history of art the contrast between Lombard
and Byzantine art in the south of Italy assumes a different aspect from that
which is found in the centre and in the north. Monuments in "Lombard" style,
such as are found in such enormous quantity in Rome and neighbourhood, very
rarely occur in the south, and even when they are to be found, they consist
mainly of small fragments. On the other hand, both the seats of Lombard rule
and the Greek cities on the coast can show remains of a sculpture which has
a character all its own. The active commerce carried on by important seaports
such as Amalfi and Naples naturally favoured the penetration of eastern art,
which was brought nearer by the encroachment of the Arabs in Sicily and the
extreme south of Italy. The number of monuments, however, is small, the dates
uncertain, and the determination of relationships very difficult. Despite the

57

thorough investigation of this part of the country by Bertaux, science is still faced with numerous difficult problems. At the suggestion of the author of the present volume Franz Dibelius was preparing a work on the development of art in Campania, but owing to his untimely death in the war this work has remained unfinished and as yet unpublished.

The beginnings of Christian sculpture in the south of Italy are still veiled in complete obscurity. The first information which we possess dates from the time of the Byzantine and Lombard conquests. Curiously enough certain monuments of later date furnish the proof of a survival of late antique traditions in these regions, although we are unable to establish the intermediary stages. An example of this kind is the very remarkable sarcophagus preserved *Plate 62* at the cathedral of Calvi, where it has been built into the wall and serves as lintel to the doorway. A fragment in the museum at Capua forms a pendant to this sarcophagus. The decoration is based on a *motif* frequently found on Roman sarcophagi, namely, two Tritons astride of waves, with women riding on their backs, and holding a medallion containing the likeness of the deceased. Despite the external imitation of the antique models, the complete absence of skill in representation cannot be denied. The waves have become a species of ornamentation, the limbs, shown in active movement, are flatly superposed in layers, the portrait is entirely lacking in individual characteristics. As if to emphasize the Lombard origin a strip of interlace is placed as an ornament on one of the lateral rims of the sarcophagus, and in view of this fact the sarcophagus can hardly be dated earlier than the eighth century. But this later origin suffices to give the work a special importance. While these sarcophagi already show the wide gap which separates the Lombard sculpture of Capua from all other monuments of the kind found in north and central Italy, the difference is still further emphasized by the fragments *Plate 63* found in 1912 in the church of San Giovanni a Corte at Capua, on which are represented groups of men and women. These fragments are the remains of large simply-framed reliefs, containing a series of portrait-figures, the stylistic treatment of which, especially in the draperies, coincides with that of the portrait-medallions. The figures are more or less frontal, but the gestures and position of the heads are utilized to turn them towards one side or the other. It is difficult to determine how this composition was brought together. The figures are doubtless modelled from actual personages, and Dibelius believed

58

that they represent the family of Count Lando, the founder of the new Capua which arose in the middle of the ninth century. It is to be hoped that careful researches carried out on the spot may supplement our knowledge of this monument, which holds a unique position in the history of early mediaeval art.

These tombstones and pictures of donors justify the supposition that other representations of figures were by no means uncommon in these regions, while on similar monuments in northern and central Italy only insignificant ornamentation is found. The relief in the museum at Capua, showing an archangel standing on steps, must also have been a part of some important monument of the same period. Cattaneo described it as a "barbarian" work but added that it was the "least barbarian" of those executed by the Greeks in Italy during the eighth century. If we compare it with the celebrated Byzantine ivory tablet in the British Museum, this opinion seems justified, but when we consider the imitation of Byzantine models on the Pemmo altar, the Capua angel seems an astonishing achievement, which can only be properly understood if we consider it in relation to the sculptures already mentioned. It is a very remarkable fact that we find the same contrasts of style in these regions as at Cividale. At the time when Heinrich Wilhelm Schulz was engaged in his researches on the monuments of southern Italy, there existed in the church at Cimitile a mediaeval pulpit in the construction of which older panels had been re-used. It is not surprising that among these panels should be found some on which are represented animals in pairs against a background of foliage and trees in the Byzantine style. On the other hand there is another panel showing oxen and lions in similar arrangement, but of such a completely different character and so "barbarically" stylized, that Bertaux has refused to believe that they can have formed part of the same monument. As a matter of fact, the latter work is strongly reminiscent of the Sigvald panel at Cividale, and in this way a curious connection with the artistic customs of that northern Italian centre of Lombard art is established. The contrast of style between the various panels is really not so remarkable as Bertaux thought, for similar contrasts may be observed on the Sigvald panel between the peculiar Symbols of the Evangelists and the Byzantinizing style of the little griffins.

Plate 64

The close relationship with Byzantine and oriental art which appears in the Capuan monuments must certainly have been transmitted as a result of the proximity of the seaports. Unfortunately, at Naples very little has been pre-

served, and the dating of such monuments as do exist has given rise to much
Plate 65 discussion. A celebrated masterpiece is the calendar, carved in a block of marble and decorated on the back with a frieze, formerly in the church of San Giovanni Maggiore and now preserved in a mutilated condition in the archiepiscopal palace. Since the learned researches of Mazochi in the eighteenth century, the composition of this calendar is generally dated from about the year 850, and Bertaux believes that the monument itself must have been created about the same time. He also supposes that the monument was placed in the church in the manner of an iconostasis. The representations on the back of the panel contain a double row of regular foliage tracery, amidst which are seen winged horses, lions and griffins in pairs. The middle of one of the strips is marked by a vase. The fantastic animal world which we find here in the midst of well-designed foliage is no novelty, and we have already referred to its origin and probable transmission by means of textiles, a theory with which Bertaux also agrees. But the strange feature in this monument is that the reliefs do not show the superficial treatment which is usually found in northern Italian monuments, but a modelling which, though concise, is nevertheless combined with an advanced linear treatment of the details. This sudden appearance of plastic modelling seemed so inexplicable to Venturi and Toesca, that they were inclined to assign these reliefs, together with any other works which can be related to them, to the eleventh or twelfth century. We, on the contrary, prefer to accept the earlier date given by Bertaux and after him by Wulff and Dibelius. There is really nothing abnormal in this departure from the usual line of development of marble sculpture if we remember that during the period in question Naples must have been in particularly close touch with the art of the East.

These problems present themselves in an even clearer form in the choir-
Plate 66 screen panel in San Giovanni Maggiore, the origin of which Bertaux considers must be closely connected with the panels of the calendar. This much-damaged and no longer complete panel contains in its principal compartment a stag and a hippogriff standing opposite to each other. Behind them the background is filled in with foliage, in the midst of which various animals are represented. On the left rim a staircase flanked by columns is seen, which in a rather mysterious manner seems to dissolve into twists in a downward direction. If we leave aside these problems of subject, we still have to admit that the two large

and beautifully modelled figures of animals are a real miracle, for they display a plastic talent which is not to be found in any other work of the period. We do not believe that a reference to the style of the twelfth century can suffice to explain this problem. Obviously we have to do with another work the stylistic relationships of which are at present unexplained. In this connection another remarkable fragment of arcading with ornamental fillings, now in the Kaiser Friedrich Museum at Berlin, is also important, for it too appears to have come from San Giovanni Maggiore, and Wulff attempted to date it from the sixth and seventh centuries and to relate it to the influence of Persian art.

Among the few works which have been preserved in Naples itself may be mentioned the choir-screens in the little church of Sant'Aspreno, which have considerable importance. On these panels is depicted a frieze in flat relief with rhomboid-shaped spaces filled in with little representations of vases, plants, and real and fabulous animals. The animals are depicted partly in peaceful attitudes, and partly hunting. The influence of fables is evident, for example in the cock holding the writing-tablet and teaching. The stylization of the details again points to a familiarity with oriental textiles. The Greek inscriptions furnish us with the names of two donors of whom we know nothing further. Capasso dates these inscriptions from the tenth century at the latest, and Toesca makes no objection to this theory in view of the shallow cutting of the reliefs. On the other hand the age of a series of relief panels in the museum at Sorrento has been much disputed. The latter consists of a series of small, rect- *Plate 67* angular marble panels, to which may be related certain others preserved in the Museo Baracco at Rome and in the Kaiser Friedrich Museum in Berlin. All these panels contain in their ornamental framework representations which are reminiscent of the oft-mentioned oriental fabrics containing figures of animals. They consist either of single animals such as the griffin, hippogriff or eagle, depicted in proud attitudes, or else of pairs of animals arranged at the sides of a fountain or a tree. These panels must originally have possessed a composite frame, the form of which may perhaps be indicated by the tombs in the atrium of St. Mark's. Similar themes are found on a whole series of larger choir-screen panels, on which are depicted hippogriffs in pairs drinking by a fountain, griffins on either side of a tree, and similar subjects, while the trees *Plate 68* with their branches and large leaves are arranged to form a background. These panels are in pronounced relief, shown, however, in the form of layers. In size

61

and in their rigid stylization these panels are more effective than any other similar works found in Italy. Unfortunately we have no clue as to their date, but the latest period to which they can be assigned is the eleventh century, and they thus represent a remarkable pendant to the choir-screen panels in Torcello, which, despite the similarity of subject, are completely different in style.

We must not forget the fact that this sculpture probably survived for a long time in southern Italy and that many monuments which appear to continue the above-mentioned traditions may perhaps have originated in the eleventh or even in the twelfth century. To these belongs the large and magnificent *Plate 70* panel, showing two frontally-depicted peacocks, in the cathedral at Atrani, a pendant to which, though stylistically very different, is preserved in Venice.

Lastly we may mention at this point a group of monuments, which appears to constitute an exceptional occurrence for southern Italy, namely the pulpits of which the staircase-panels contain representations of the story of Jonah. This conception probably originated in Constantinople or at all events in the East. The pulpit in verd-antique from the Hagia-Sophia at Salonica appears to confirm this. In southern Italy the *motif* must have been introduced at a very early period, as the very ancient remains of a pulpit in Capua testify. The representations in the eleventh-century Exultet-rolls are a further proof of its popularity. Of the older examples, the panels which during the later part of the Middle Ages were used again for the pillared pul- *Plate 69* pit in the cathedral at Traetto-Minturno are worthy of mention. These panels show the tendency to a genre-like development of the scenes and to fantastic representations of the whale. At a later period the pleasure in representing the whale as an elegant and superb monster became so intense that Jonah was finally quite forgotten. Similar panels are preserved in the museum at Sorrento, and in the church at Positano, and even in the distant city of Bari a similar fragment of a pulpit is found, though the latter shows notable differences in stylization.

VIII

RENAISSANCE TENDENCIES FROM EAST AND WEST

THE most puzzling element in the history of Italian sculpture during the early part of the Middle Ages has always been the fact that the greater part of the productions of the so-called Lombard marble sculpture occur in the very period which saw the zenith of the Carolingian Renaissance in the West under Charlemagne and his successors, to be followed a few years later in the East, after the close of the Iconoclastic Controversy and under the Macedonian dynasty, by the second Golden Age of Byzantine art, which has been called the Byzantine Renaissance, because it takes up the threads of development at the point where they had been interrupted in the confusion of the post-Justinian era.

To what extent did Italian sculpture come in contact with these movements and what influence did they exert?

Curiously enough, the concentration of attention on the Lombard marble sculpture, often excellent in its decoration but always "barbarian" in its representations of figures, has been the cause of much perplexity. A glance at French art would have sufficed to show that a similar "barbarian" marble sculpture also flourished in that country despite the simultaneous Renaissance movement. This similarity is so strong, that it enabled de Lasteyrie to construct a theory according to which Lombard sculpture would have first appeared as a consequence of the invasion of the Franks. In the course of this attempt to prove the derivation from France of Italian marble sculpture, the very work which most clearly proves the penetration into Italy of Carolingian Renaissance art, namely the high altar of Sant'Ambrogio in Milan, was completely misunderstood. An apparent foundation to this error was given by the circumstance that at some time before 1196 a part of the vaulting of Sant'Ambrogio collapsed and the pulpit was damaged. On these grounds a theory was advanced that the high altar must have been destroyed as well, but the evidence of our own eyes proves exactly the contrary.

The high altar of Sant'Ambrogio is the most precious relic we possess of *Plates 71, 72* mediaeval goldsmiths' work, the only work that can give us an idea of the magnificence with which the churches of the period were decorated. The altar is

63

covered on all four sides with plates in precious metal on which are representations in embossed work, and with a rich decoration of precious stones, gems and enamels. The front consists, as we know from Tarchiani's careful investigation, of gold; the remaining three sides are of gilded silver. The date is assured by a detailed inscription and by two of the figures, one representing Archbishop Angilbert II (824-859) and the other the *magister phaber Vvolvinius*.

The characteristics of this altar are perfectly uniform, if we exclude the Baroque substitution of a few compartments after a theft committed in 1590, and it is quite wrong to assert that the damage and restoration which the altar has perforce undergone in the course of time have disfigured its style.

The peculiar position of this altar as regards the rest of Italian art has recently been strongly emphasized by Toesca, who declares that there is no work in Italy produced between the eighth and eleventh centuries which can show even a remote resemblance to it and that it must therefore be explained as due to the influence of Frankish Renaissance art, while the artist Vvolvinius may even have come from beyond the Alps. This latter conjecture is all the more difficult to establish, when we remember that in those days artists were sent abroad to complete their artistic education, a point to which Leidinger drew attention in his studies on the related binding of the Codex Aureus. The stylistic origin of such goldsmiths' work lies in the North of France, their ultimate source being the influence, exercised since the first quarter of the ninth century by Rheims and Hautvillers, which at the time of Charles the Bald found a new centre of production at Corbie, as Leidinger has recently endeavoured to establish in the face of all objections. The connection between painting, ivory-carving and goldsmiths' work in such workshops has been emphasized by W. M. Schmid, Swarzenski, Goldschmidt, Leidinger and others.

The peculiarity of the fundamental stylistic tendency of Carolingian art consists largely in this close connection between painting and sculpture. It can be proved that ivory-carvers copied integrally the compositions of paintings, and moreover that they endeavoured to transform into sculpture the exceptional freshness and vivacity of narration attained in painting by an easy technique of sketching. If we also consider that the school of Rheims and those depending from it are connected, in a manner which has yet to be fully explained, with the illusionist painting of the late antique period, it becomes easy to understand the peculiar character of the works which resulted therefrom.

64

On the Vvolvinius altar the stylistic connection between the Majestas Domini and the scenes from the New Testament on the front is particularly striking. It is also recognizable in the twelve scenes on the back depicting incidents from the life of St. Ambrose narrated according to the Life of the saint by the Diaconus Paulinus (with the exception of the scene referring to the burial of St. Martin at Tours, which is derived from the writings of Gregory of Tours), although in this case the stylization seems to take a rather firmer and more rigid direction. The unity of character is not destroyed, however, and if we compare the Vvolvinius altar with the goldsmiths' work produced at approximately the same time for Pope Paschal I, we can obtain a full idea of what the Carolingian Renaissance represented in the transformation of artistic creation.

As we have already mentioned, Toesca has emphasized strongly the unique position which this altar occupies in the history of Italian art. Vitzthum, on the other hand, tries to prove, like Bertaux before him, that the relationship to Frankish art is not really so close, and to establish a connection between the altar and the ciborium under which it stands.

The opinion of art historians as to the ciborium has undergone the same variations as has been the case with the altar itself. The collapse of the vaulting prior to the year 1196 is assumed to have affected the ciborium also, which in this case could at the earliest be a work dating from about the year 1200. *Plates 73, 74* The improbability of such an assumption appears to us to be obvious, although even such prominent connoisseurs of Italian art as Venturi, Toesca and Kingsley Porter have recently supported this theory. Bertaux was undoubtedly right when he classified the ciborium, like the stucco figures in Cividale, among those works which, while constructed in less costly materials, serve to give us an idea of the lost works in precious metals. The small portable altar of the Emperor Arnulf in the Reiche Kapelle at Munich proves to us that ciboria similar to that at Milan were produced by the same class of goldsmiths as that to which Vvolvinius belonged. Despite this coincidence, however, we are unable to accept the assertions of Bertaux, Albizzati and Vitzthum regarding an alleged affinity of style between the altar and the ciborium. Even if we only use for purposes of comparison the tranquil and solemn figures on the back of the altar, those of the ciborium seem hieratically rigid; and this rigidity corresponds to a simplificaction of the folds of the drapery by means

65

of linear grooves and a distribution of the relief into obvious layers which are intended to give the impression of round modelling. This undoubtedly deliberate simplicity is really only violated in the representation of the delivery of the book and the keys to Peter and Paul on the front of the ciborium, where it is replaced by a more elaborate treatment of the borders of the vestments, very reminiscent of the stylization of the so-called Ada group.

Despite all these similarities, however, we are disinclined to assign the ciborium to the Carolingian epoch. There appear to us to be many proofs to the contrary, which enable us to bring the ciborium into relationship with a somewhat more recent group of small sculptural works in Milan. The definite starting-point for this theory is the ivory holy-water stoup in the treasury of

Plate 75 Milan Cathedral, which Archbishop Gottofredo (974/75-980) caused to be prepared for the reception of the Emperor Otho II. Another stoup in the Hermitage was also made, according to the inscription, for the coronation of an Emperor Otho (II or III). The figure-representations derive from an Early Christian diptych preserved in Milan, and lastly, Prince Trivulzio possesses in

Plate 76 Milan an ivory relief representing the family of an Emperor Otho (I or II) at the feet of Christ and of St. Maurice and the Virgin. To these three works, all of them connected with the Ottonian imperial family, of which one was made for an Archbishop of Milan and another was derived from a diptych preserved in Milan, a whole series of ivory reliefs is more or less closely related. Among them we may give the first place to the remains of an antependium presented to the cathedral of Magdeburg, apparently by Otho I.

In view of this, we are naturally inclined to seek the centre of this school of ivory-carving in Milan, at least as far as the first three works are concerned. In fact Goldschmidt, who was the first, in the corpus of his work on ivories, to assemble the whole group, expresses this belief, but advances subsequently a second hypothesis — based on grounds which we do not find convincing — whereby he proposes as a possible place of origin the convent of Reichenau, and this renders doubtful the apparent certainty which the Milanese holy-water stoup seemed to offer. We prefer to leave the question open as to whether the large group of reliefs centring round the Magdeburg antependium must have originated from the same place as the group related to the holy-water stoup in Milan. R. Berliner is also inclined to accept the theory of a separation, which would add another example to the workshop-relationships between northern

66

Italy and Germany or Switzerland; but we prefer to maintain our assertion that Goldschmidt's first idea was correct, and our conviction is strengthened by the fact that the ciborium clearly appears to possess a general stylistic affinity with the products of this school of carving. If we extend the comparison to the style of relief and the deliberate simplicity of the outlines and draperies, and also to the modelling of the heads with the marked preference for rather broad, round heads with wig-like hair, and for long pointed beards, we should be going beyond the limits which we have set ourselves. For us the matter seems to be settled if we bear in mind what a great difference exists between large works in stucco, preserved in a state which renders any judgement difficult, and generally painted over, and a small ivory relief. As regards the interval of time the problem needs very careful examination. The ciborium affords a clue in its dedication relief, which, however, bears no inscription, or perhaps it would be better to say that no inscription has been preserved to the present day. Every fact which we can deduce from the ivory reliefs points to a period later than the middle of the tenth century.

In the eleventh century a free imitation of this ciborium was made for the monastery church of San Pietro near Civate, but the rich stucco decoration of the church and of the ciborium differs widely both in subject and style from the ciborium in Milan, and show obvious traces of the new tendencies determined on the one hand by the influence of the middle Byzantine period and on the other by the rise of the new school of Lombard sculptors.

The mention of the Milanese ivory works from the time of Bishop Gottofredo leads us to another question, namely, whether the centre of this school was in northern Italy, in one of the Alpine monasteries, or even in Germany, or whether we are to assume so close a degree of relationship between these different centres of production that the place of origin of the individual works produced thereby must as a necessary consequence remain doubtful. Goldschmidt has remarked on certain features in other of the works in question which point to their having originated in the schools of the Alpine monasteries, but admits all the same that a definite decision cannot be given. This is certainly the case with the binding of the communion-book dating from the time of King Berengarius I (888-916), and now preserved in the treasury of the cathedral at Monza. The ornamental *motifs* of this work may, it is true, be compared with the marble sculptures of the period, but they nevertheless

Plate 77 possess a refinement which is generally limited to the small works of sculpture. The same may be said of the so-called ivory Pax in the museum at Cividale, on which a certain Duke Ursus is mentioned as the donor. Goldschmidt, on account of the similarity of style, especially in the draperies, has ascribed this latter work to the school of carving which existed in St. Gall about the year 900. The stylistic resemblance, in our opinion and also in that of Toesca, is not sufficiently evident to render this supposition a certainty, but Goldschmidt is certainly right as regards the dating. It is permissible to suppose that this Duke Ursus, who has not yet been identified with certainty, may have been the donor of the ciborium in the parish church of San Leo near Rimini, which is dated 882. It is thus probable that this ivory tablet is of north Italian origin, although it has not yet been possible to connect it with any of the larger groups. The style of the tablet is stiff and ungainly, the folds of the draperies consist of parallel grooves crowded closely together. The same inadequate treatment is also found on the rare figure-sculptures in marble both in northern Italy and in other countries. The Pemmo Altar already mentioned may be taken as an example, though at this stage we may also consider a few more recent works which stand more or less alone. The stone sarcophagus of the saints Lucillus, Lupicinus and Crescentianus in the crypt of San Zeno at Verona, which Kingsley Porter in a recent work endeavoured to assign to this stage of sculptural development, cannot, despite the resemblance in the play of the draperies, date from so early a period. It must on the contrary be a relatively late work in a peculiar style, showing a remote relationship to sculptures like those on the pulpit at Massa Marittima. Mention must be made at this point, however, of the little relief representing a prince, on the font of the small temple in Spalato. Strzygowski compares it with Lombard sculptures, although he supposes that the prince represented is one of the ancient Croats. In any case the fixing of the date between the ninth and eleventh centuries becomes rather difficult. Equally uncertain is the date of the choir-screen panels with reliefs representing scenes from the youth of Jesus in the Donatus Museum at Zara, for which dates varying from the eighth to the eleventh centuries are given. The decoration of a long row of panels with biblical stories is very unusual. Probably the later date is the right one, and the difference of opinion which exists among learned investigators on this point only shows the perplexity to which the very simplicity of the style has given rise.

68

Isolated like the Ursus tablet is the diptych from Rambona (in the neigh- *Plate 78*
bourhood of Ancona), now preserved in the Christian Museum at the Vatican,
which we may mention at this point as another very important specimen of
Italian ivory-carving. This diptych, unusual both in the subject, which re-
presents the she-wolf suckling Romulus and Remus beneath a Crucifixion,
and in the style, which is far removed from the primitive methods of the Ursus
panel, bears inscriptions in which the founder of the monastery, the Empress
Ageltruda, and the Abbot Odelricus, are mentioned, which appears to make
it certain that the date of the work must lie round about the year 900. This
is yet another proof of the varied nature of the productions of that epoch,
and of the surprises which every object that has been preserved may offer to
investigators of the subject.

The above researches have led us by devious ways to the shores of the Adria-
tic, which at this epoch was the scene of some very remarkable artistic con-
flicts. We have hitherto followed in the wake of the Lombard style, which
extended its influence both on the Italian and on the Croatian side of the
Adriatic. It is possible that Carolingian art, as a result of political events, may
have penetrated to this region; for we know, to take an example, that one of
the protagonists of the Frankish party, the Patriarch Fortunatus of Grado
(803-826), summoned artists from the kingdom of the Franks. The strongest,
and, from the point of view of art history, the most important factor in the
artistic development of these regions remains, however, the art of Byzantium,
which penetrated for the second time into Italy through Venice, where the re-
lations with the Byzantine empire had been preserved, conferring upon this
city an importance equal to that of Ravenna in a former epoch, and subse-
quently exercised a very powerful influence on the rest of Italy.

Hitherto we have examined the Byzantine-oriental influences mainly with
regard to their effect upon decorative sculpture, but we must now turn our
attention to the problem as to from what time and to what extent the new art
of the Byzantine Renaissance succeeded in exercising an influence on figure-
sculpture. To answer this question is a difficult matter. The number of monu-
ments which have been preserved is unusually large, but we also know that
Venice is full of articles of booty which the Venetians brought from far and
near to adorn their city and which consequently have a very slight connec-
tion with the development of art in Venice itself. But quite apart from these

spoils of war, any attempt at classification in accordance with their style of the works preserved encounters many formidable obstacles. We are confronted with the problem of separating the original Byzantine works brought to Venice, and those created in Venice by Byzantine artists who had been summoned thither, from those produced by their Venetian pupils and by imitators. No definite indications exist which can in any way help us, and under these circumstances it is easy to understand how even studies conducted with enthusiasm and exactitude, such as those of Cattaneo and Von der Gabelentz, do not result in a unanimous and definite classification, and even how a very prudent critic like Toesca can be brought to maintain that a solution of the problem is impossible.

The position is naturally particularly difficult as regards the ninth and the early part of the tenth centuries. We know from various sources that the Byzantine influence had firmly established itself at this time, for we are told that the emperor Leo V (813-820) even at that early period sent his master-masons to Venice, and the above-mentioned Patriarch Fortunatus of Grado relates that the "capsae" (reliquary-shrines?) which stood on two of the magnificent altars with which he decorated his church, were purchased in Constantinople. The remains of a ciborium which, after the expulsion of the above-mentioned patriarch, his successor John the Younger (814-818) presented to the church of Santa Maria, display a palm-frieze which is the very antithesis of Lombard art, and can only be explained as a consequence of the close relations which existed with the art of the East. But while Cattaneo so far is undoubtedly right, his conclusions as to the dating of the monuments of the period are, as Toesca points out, for the most part doubtful. In view of the conservative nature of Byzantine art and the numerous difficulties which have already been mentioned, a decision in each individual case can only be given after much careful study and under certain reservations. It is not until the year 1000 that things begin to be a little clearer, for we possess in a number of towns on the coasts of the Adriatic remains, apparently from this period, of church-decoration in marble (for example, in the museum at Bari, and at Ancona in Santa Maria in Piazza). In Venice itself a large proportion of the breastwork-panels placed in various parts of the church probably date from the time of the reconstruction of St. Mark's in 976. In the cathedral at

Plate 79 Torcello, where choir-screen panels and the pulpit are still to be found in

their original positions, the date of the construction of the cathedral, given as 1008, although it has been the subject of considerable discussion, appears to afford a fairly certain clue. In contrast to the flat style which was widely diffused even in the East during the preceding centuries, these panels show a richer modelling in the profiled frames and in the scenes carved in relief, although the relief-work is for the most part very delicate. Apart from a few exceptions, these representations remain within the well-known limits of decorative or symbolical *motifs*. Very frequent are the panels with geometrical patterns in the style known as the embroidery or passementerie style, which shows a preference for rectangular or rhomboid patterns made up of interlaced bands, or else for representations of animals, the similarity of which with those of the Neapolitan school we have already mentioned. The choir-screen panels at Torcello are rightly celebrated; they represent a pair of peacocks drinking from the tall basin of a fountain, and lions on either side of a tree, amidst the foliage of which room has been found for all kinds of animals. Curiously enough, these representations are found in Torcello in double form, though there exist, as Muñoz has observed, certain stylistic differences, which seem to denote that they are model and imitation or else the work of master and pupil. Very unusual is the framework of the Torcello panels, which shows a circular interlace pattern regularly repeated in the borders with fillings of rosettes. This is reminiscent of the framework to be found on those strange Byzantine ivory caskets which for this reason are generally known as star-caskets.

These star-caskets are recognized as one of the most curious features in the realm of Byzantine art, for they generally contain representations drawn from ancient mythology together with resemblances to models which in some cases we are still able to trace. In Torcello we also find two marble panels with cognate *motifs* of a most surprising nature. One of them represents Ixion *Plate 80* tied to the wheel, between two figures; the other Kairos, the favourable moment, departing on winged wheels; one of them has lost his chance and is already assailed by remorse, the other takes time by the forelock and is crowned by Fortune. Both these panels, however, are so different in their framework from the above-mentioned choir-screen panels that it is not possible to assign them definitely to the same period.

These reliefs lead us right into the midst of the difficulties mentioned above. Subjects from ancient mythology, and especially from the legend of Hercules,

71

are to be found on large marble reliefs preserved in St. Mark's and in the museum at Ravenna. Some of them are obvious imitations dating from the latter part of the Middle Ages, of the relationship of which we shall speak on another occasion; others, on the contrary, are so close to the antique that they must be either of the late antique period or else astonishingly skilful imitations.

In this period also the choir-screen panels, and other breastwork-panels in general, apart from the ornamental decoration, contain no biblical representations; but we know already that from the end of the tenth century Byzantium flooded the West with small ivory reliefs, on which were represented biblical stories and histories of saints, all bearing the clear imprint of the middle Byzantine style. It cannot be doubted that at the same period there originated a marble sculpture, the chief task of which was the production of large icons. It only remains to be seen whether the large number of works preserved in St. Mark's and in the coast-towns of the Adriatic such as Caorle, Ravenna and Ancona, include works of this early period and whether they form part of the booty brought back by the Venetians, or whether even at that early period they were specially made for the churches of the West. Of great importance in this connection is the relief of the Madonna in the church of Santa Maria di Dionisio at Trani, the inscription on which names a Byzantine, Turmarcha Delterios (1039).

The year 1000 thus marks the penetration into the east of Italy of Byzantine icon sculpture with its graceful style based on that of the antique ivory reliefs, and from this point onwards we are able to follow its influence on the development of Italian art. This brings us, however, to the beginning of Romanesque sculpture, the study of which will form the subject of another volume.

BIBLIOGRAPHY

ABERG, NILS. Die Goten und Langobarden in Italien. Upsala, 1923.

AINALOW, D. The Hellenistic Bases of Byzantine Art. Leningrad, 1900 (in Russian).

ALBIZZATI, CARLO. Il ciborio carolingio nella Basilica Ambrosiana di Milano. Atti della Pontificia Accademia Romana di Archeologia, Serie III, Rendiconti II, 1923-1924.

BERLINER, RUDOLF. Die Bildwerke des Bayerischen National-Museums: die Bildwerke in Elfenbein. Augsburg, 1926.

BERLINER, RUDOLF. Aus der mittelalterlichen Sammlung des Bayerischen National-Museums, in Münchener Jahrbuch der bildenden Kunst, XII, 1921-1922.

BERTAUX, ÉMILE. La Sculpture en Italie du VIe au Xe Siècle, in Michel, Histoire de l'Art, I. Paris, 1905.

BERTAUX, ÉMILE. L'Art dans l'Italie Méridionale. Paris, 1904.

BRŒNDSTED, J. Early English Ornament. Copenhagen-London, 1924.

CAPPS JR., EDWARD. The Style of the Consular Diptychs. The Art Bulletin, X, 1927.

CATTANEO, RAFFAELE. L'Architettura in Italia. Venice, 1888-90.

CECCHELLI, CARLO. Arte Barbarica Cividalese, in Memorie Storiche Forogiuliesi, Anno 16-17, Udine, 1920.

CECCHELLI, CARLO. Il Tempietto Langobardo di Cividale, in Dedalo, III, 1923.

COLASANTI, ARDUINO. L'Art Byzantin en Italie. Paris, n. d.

CONWAY, SIR MARTIN. A Porphyry Statue at Ravenna, in Burlington Magazine, XXII, 1912-1913 (see also Felix Ravenna, 1914).

COURAJOD, LOUIS. Leçons professées à l'École du Louvre, I. Paris, 1899.

DALTON, O. M. Byzantine Art and Archaeology. Oxford, 1911.

DALTON, O. M. East Christian Art. Oxford, 1925.

DELBRUECK, RICHARD. Antike Porträts. Bonn, 1912.

DELBRUECK, RICHARD. Bildnisse römischer Kaiser. Berlin, n. d.

DELBRUECK, RICHARD. Porträts byzantinischer Kaiserinnen, in Römische Mitteilungen, 1913.

DELBRUECK, RICHARD. Carmagnola, in Römische Mitteilungen, 1914.

DELBRUECK, RICHARD. Ein spätantiker Kaiserkopf, in Berliner Museen, Berichte aus den Preussischen Kunstsammlungen, XLIV, 1923.

DELBRUECK, RICHARD. Die Konsulardiptychen und verwandte Denkmäler. Berlin-Leipzig, 1926-29.

DELBRUECK, RICHARD. Deckelpaar in Mailand, Domschatz, in Antike Denkmäler, published by the Deutsches Arch. Institut, Vol. IV, 1927.

DIBELIUS, F. Eine Gruppe spätantiker Sarkophage, in Römische Quartalschrift, XXIV, 1910.

DÜTSCHKE, HANS. Ravennatische Studien, Beiträge zur Geschichte der späten Antike. Leipzig, 1909.

FROTHINGHAM, ARTHUR L. The Monuments of Christian Rome. New York, 1908.

FURTWÄNGLER, ADOLF. Das Tropaion von Adamklissi und provinzial-römische Kunst, Abhandlungen der philosophisch-philologischen Klasse der königlichen Bayerischen Akademie der Wissenschaften, XXII. Munich, 1905.

GABELENTZ, HANS VON DER. Mittelalterliche Plastik in Venedig, Leipzig, 1903.

GARRUCCI, RAFFAELE. Storia dell'Arte Cristiana, 6 volumes, Prato, 1879.

GEROLA, GIUSEPPE. Galla Placidia e il cosidetto suo mausoleo in Ravenna. Bologna, 1912.

GEROLA, GIUSEPPE. Sarcofagi Ravennati inediti, in Studi Romani, II, 1914.

GEROLA, GIUSEPPE. Il Monogramma della Cattedra Eburnea di Ravenna, in Felix Ravenna, No. 19, 1915.

GIOVENALE, G. B. La Basilica di Santa Maria in Cosmedin. Monografie sulle chiese di Roma, II. Rome, 1927.

GNECCHI, FRANCESCO. I Medaglioni Romani, 3 volumes. Milan, 1912.

GOLDMANN, KARL. Die Ravennatischen Sarkophage. Strasburg, 1906.

GOLDSCHMIDT, ADOLPH. Die Kirchentür des hl. Ambrosius in Mailand. Strasburg, 1902.

GOLDSCHMIDT, ADOLPH. Die Elfenbeinskulpturen aus der Zeit der karolingischen und sächsischen Kaiser. Berlin, 1914.

GRAEVEN, HANS. Frühchristliche und mittelalterliche Elfenbeinwerke aus Sammlungen in Italien. Rome, 1900.

GRAEVEN, HANS. Frühchristliche und mittelalterliche Elfenbeinwerke aus Sammlungen in England. Rome, 1901.

GRAEVEN, HANS. Fragment eines frühchristlichen Bischofsstuhles im Provinzialmuseum zu Trier, in Bonner Jahrbücher, 105, 1900.

GRAEVEN, HANS. Heidnische Diptychen, in Römische Mitteilungen, 1913.

HÄNDEL, MAX. Untersuchungen über den Ursprung des Zangenfrieses am Grabe des Theoderich, Dissertation. Darmstadt, 1913.

HASELOFF, ARTHUR. Ein altchristliches Relief aus der Blütezeit römischer Elfenbeinschnitzerei, in Jahrbuch der kgl. Preussischen Kunstsammlungen, XXIV, 1903.

74

HAUPT, ALBRECHT. Die älteste Kunst, insbesondere die Baukunst der Germanen, first edition, Leipzig, 1909; second edition, Berlin, 1923.

HEIBERG, J. L. Italien, spredte studier og rejseskitser. Copenhagen, 1904.

HOPPENSTEDT, WERNER. Die Basilika San Salvatore bei Spoleto und der Clitunnotempel, Dissertation. Halle, 1912.

JOHNSON, FRANKLIN P. Byzantine Sculpture of Corinth, in American Journal of Archaeology, XXVIII, 1924.

JOHNSON, FRANKLIN P. A Byzantine Statue in Megara, in American Journal of Archaeology, XXIX, 1925.

JOHNSON, FRANKLIN P. The Colossus of Barletta, in American Journal of Archaeology, XXIX, 1925.

KOCH, HERBERT. Bronzestatue in Barletta, in Antike Denkmäler, III, 1913.

LASTEYRIE, ROBERT DE. L'Architecture religieuse en France à l'Époque Romane. Paris, 1912.

LAURENT, JOSEPH. Delphes Chrétien, in Bulletin de Correspondance Hellénique, vol. XXIII, 1899.

LAWRENCE, MARION. City-Gate Sarcophagi, in The Art Bulletin, X, 1927.

LEIDINGER, GEORG. Der Codex Aureus der Staatsbibliothek in München. Munich, n. d. (1925).

MAFFEI, SCIPIONE. Verona Illustrata. Verona, 1732.

MAZZANTI, CAV. FERDINANDO. La Scultura ornamentale romana nei bassi tempi, in Archivio Storico dell'Arte, Serie II, anno II, 1896.

MOREY, CHARLES RUFUS. The Sources of Romanesque Sculpture, in the Art Bulletin, II, 1919.

MOREY, CHARLES RUFUS. The Sources of Mediaeval Style, in the Art Bulletin, II, 1924.

MOREY, CHARLES RUFUS. The Sarcophagus of Claudia Antonia Sabina and the Asiatic Sarcophagi. Princeton, 1924.

MUÑOZ, ANTONIO. Le Rappresentazioni allegoriche della Vita nell'Arte Bizantina, in Arte, VII, 1904.

PETKOVIĆ, WLADIMIR. Ein frühchristliches Elfenbeinrelief im National-Museum zu München, Dissertation. Halle, 1905.

PORTER, ARTHUR KINGSLEY. Lombard Architecture. New Haven, 1917.

PORTER, ARTHUR KINGSLEY. The Tomb of Hincmar and Carolingian Sculpture in France, in Burlington Magazine, L, 1927.

PORTER, ARTHUR KINGSLEY. Spanish Romanesque Sculpture. The Pegasus Press, Paris, 1928.

REINACH, SALOMON. Courrier de l'art antique, in Gazette des Beaux-Arts, LXVIII, 1926, 1.

RICCI, CORRADO. Il Sepolcro di Galla Placidia in Ravenna, in Bollettino d'Arte, 1913-1914.

RIEGL, ALOIS. Die spätrömische Kunstindustrie nach den Funden in Österreich-Ungarn, first edition, Vienna 1901; second edition, Vienna, 1927.

RIVOIRA, G. T. Le Origini dell'Architettura Romana, I. Rome, 1901.

RODENWALDT, GERHARD. Griechische Porträts aus dem Ausgang der Antike, 76. Programm zum Winckelmannfeste der archäologischen Gesellschaft zu Berlin. Berlin, 1919.

RODENWALDT, GERHARD. Eine spätrömische Kunstströmung in Rom, in Römische Mitteilungen, 1921-22.

RODENWALDT, GERHARD. Der Belgrader Cameo, Jahrbuch des arch. Instituts, 1922.

RODENWALDT, GERHARD. Säulensarkophage, in Römische Mitteilungen, 1923-24.

ROSSI, G. B. DE. Spicilegio d'Archeologia Cristiana nell'Umbria, in Bollettino di Archeologia Cristiana, II, 2, 1871.

SALMI, MARIO. La Basilica di San Salvatore presso Spoleto, in Dedalo, II, 1922.

SALMI, MARIO. La Scultura Romanica in Toscana. Florence, 1928.

SCHMID, W. M. Eine Goldschmiedeschule in Regensburg. Munich, 1893.

SCHMID, W. M. Zur Geschichte der karolingischen Plastik, in Repertorium für Kunswissenschaft, XXII, 1900.

SCHULTZE, VIKTOR. Grundriss der christlichen Archäologie. Munich, 1919.

SCHULZ, HEINRICH WILHELM. Denkmäler der Kunst des Mittelalters in Unteritalien, edited by Ferdinand von Quast. Dresden, 1860.

SIEVEKING, JOHANN. Constantius Chlorus, in Münchener Jahrbuch der bildenden Kunst, XI, 1919-20.

SMITH, BALDWIN. The Alexandrian Origin of the Chair of Maximinian, in American Journal of Archaeology, 1917.

SMITH, BALDWIN. Early Christian Iconography and the School of Provence. Princeton, 1918.

SMITH, BALDWIN. A Source of Mediaeval Style in France, in Art Studies, 1924.

STOKES, MARGARET. Six Months in the Apennines. London, 1892.

STRZYGOWSKI, JOSEF. Orient oder Rom, Beiträge zur alten Geschichte, II. Leipzig, 1902.

STRZYGOWSKI, JOSEF. Das orientalische Italien, in Monatshefte für Kunstwissenschaft, I, 1908.

STRZYGOWSKI, JOSEF. Ravenna als Vorort aramäischer Kunst, in Oriens Christianus, new series, 5, 1915.

STRZYGOWSKI, JOSEF. Die altslavische Kunst. Augsburg, 1929.

STÜCKELBERG, E. A. Langobardische Plastik. Kempten-Munich, 1909.

STUHLFAUTH, GEORG. Die altchristliche Elfenbeinplastik. Freiburg i. Br.-Leipzig, 1896.

SWARZENSKI, GEORG. Die karolingische Malerei und Plastik in Reims, in Jahrbuch der Königlichen Preussischen Kunstsammlungen, XXIII, 1902.

SYBEL, LUDWIG VON. Christliche Antike. 2 volumes, Marburg, 1906-09.

TARCHIANI, NELLO. L'Altare d'oro di Sant'Ambrogio di Milano, in Dedalo, II, 1921.

TOESCA, PIETRO. Storia dell'Arte Italiana, I: Il Medioevo. Turin, 1927.

UBISCH, EDGAR VON, and WULFF, OSKAR. Ein langobardischer Helm im königlichen Zeughause zu Berlin, in Jahrbuch der kgl. Preussischen Kunstsammlungen, 1903.

VENTURI, ADOLFO. Storia dell'Arte Italiana, I, Milan, 1901; II, Milan, 1902.

VITZTHUM-VOLBACH. Die Malerei und Plastik des Mittelalters in Italien, in Handbuch der Kunstwissenschaft. Berlin-Neubabelsberg, n. d.

WACKERNAGEL, MARTIN. Die Plastik des 11. und 12. Jahrhunderts in Apulien, in Kunsthistorische Forschungen, herausgegeben vom königlichen preussischen historischen Institut in Rom. Volume II, Leipzig, 1911.

WEIGAND, EDMUND. Baalbek und Rom. Die römische Reichskunst in ihrer Entwicklung und Differenzierung, in Jahrbuch des Kaiserlichen Deutschen Archäologischen Instituts, XXIX, 1914.

WIEGAND, JOHANNES. Das altchristliche Hauptportal an der Kirche der heiligen Sabina. Treves, 1900.

WROTH, WARWICK. Catalogue of the Coins of the Vandals, Ostrogoths and Lombards in the British Museum. London, 1911.

WULFF, OSKAR. Altchristliche und byzantinische Kunst, in Handbuch der Kunstwissenschaft. 2 volumes, Berlin-Neubabelsberg, n. d.

WULFF, OSKAR. Neuerwerbungen der altchristlichen Sammlung seit 1912, in Amtl. Berichte aus den königlichen Museen, XXXV. Berlin, 1914.

ZIMMERMANN, E. HEINRICH. Vorkarolingische Miniaturen. Berlin, 1916.

ZIMMERMANN, MAX GEORG. Oberitalische Plastik im frühen und hohen Mittelalter. Leipzig, 1879.

GEOGRAPHICAL INDEX

GENERAL INDEX

PLATES 1-80

I

ROME

San Giovanni in Laterano

Portrait-head of the Emperor Constantine from the statue in the
atrium of San Giovanni in Laterano.

Photo Anderson

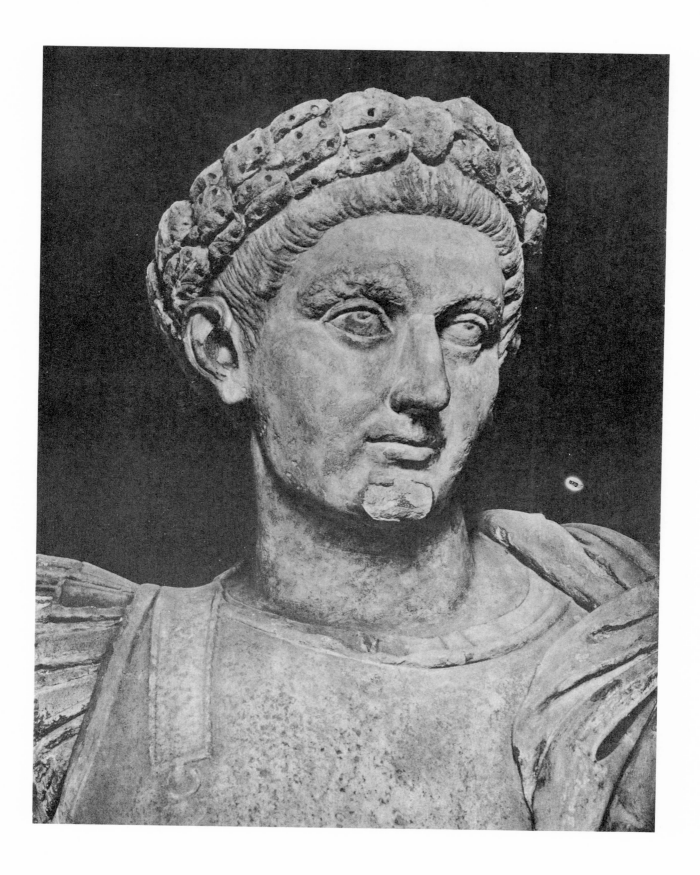

2

ROME

Palazzo dei Conservatori

Portrait-head of the Emperor Constantine from the colossal
statue in the Basilica of Maxentius.

Reproduced from Arndt-Bruckmann, Griech. und röm. Porträts, plate 891

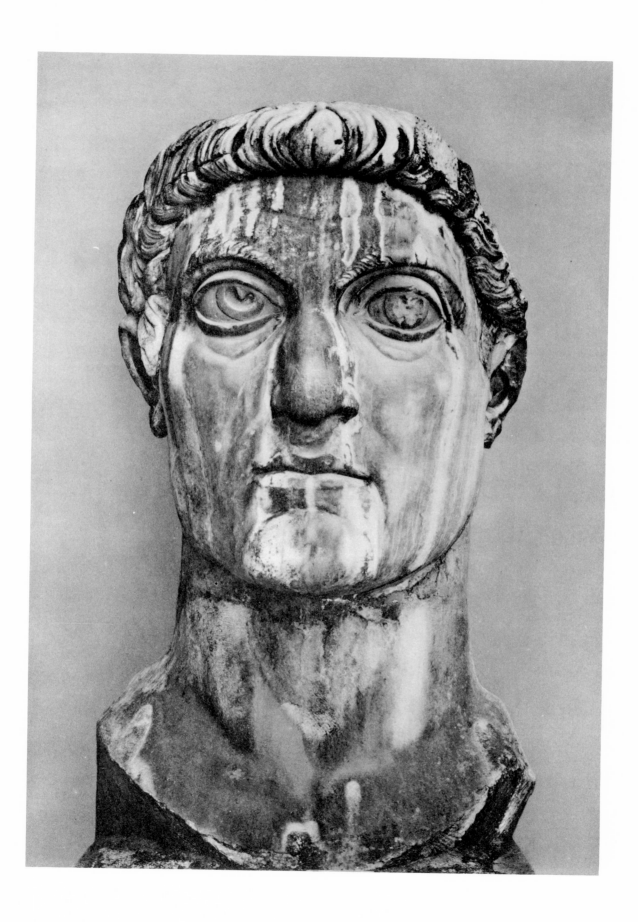

3

ROME
Palazzo dei Conservatori
Portrait-head of Constans (?).
Bronze.

Reproduced from Arndt-Bruckmann, Griech. und röm. Porträts, plate 894

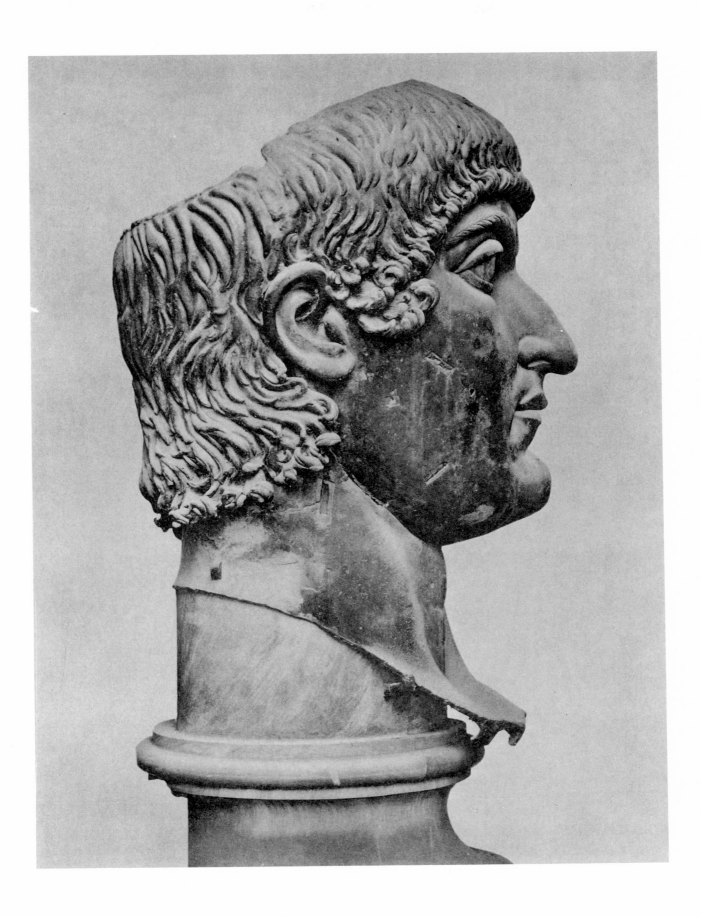

4

BARLETTA

Portrait-head of the Emperor Valentinian I (?) from the
Colossus of Barletta.

Reproduced from Antike Denkmäler, III, 1913

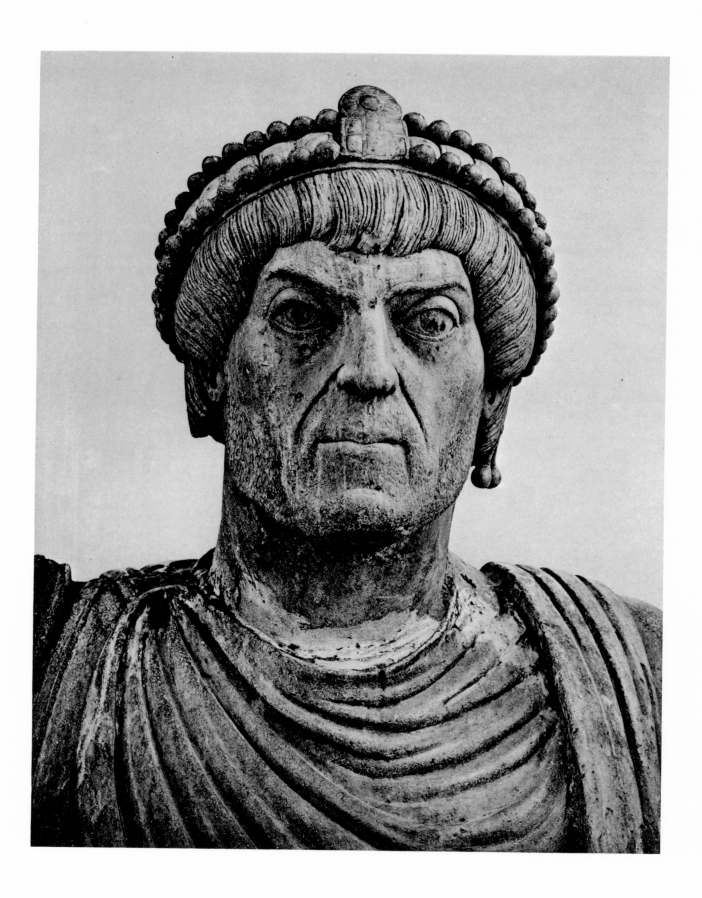

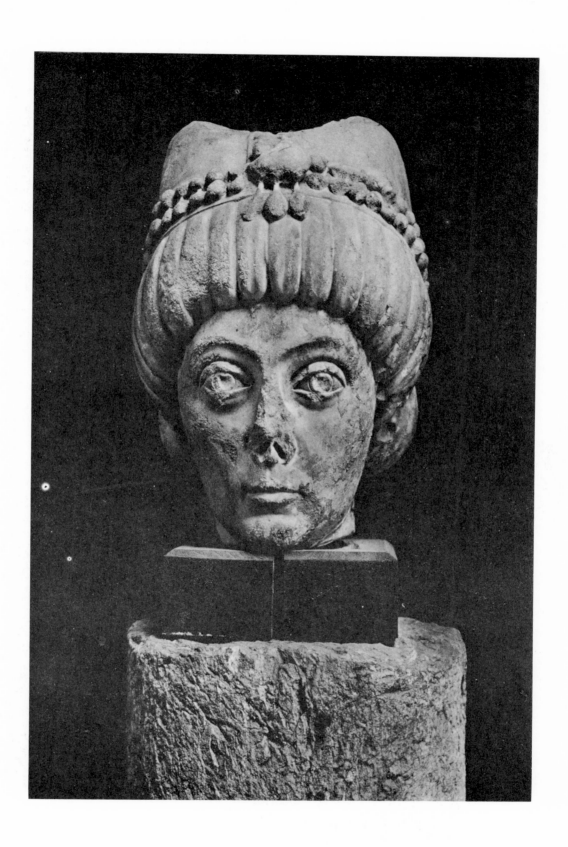

6

VENICE

St. Mark's

The so-called " Carmagnola ", porphyry head of an emperor of
the late antique period.

Photo Anderson

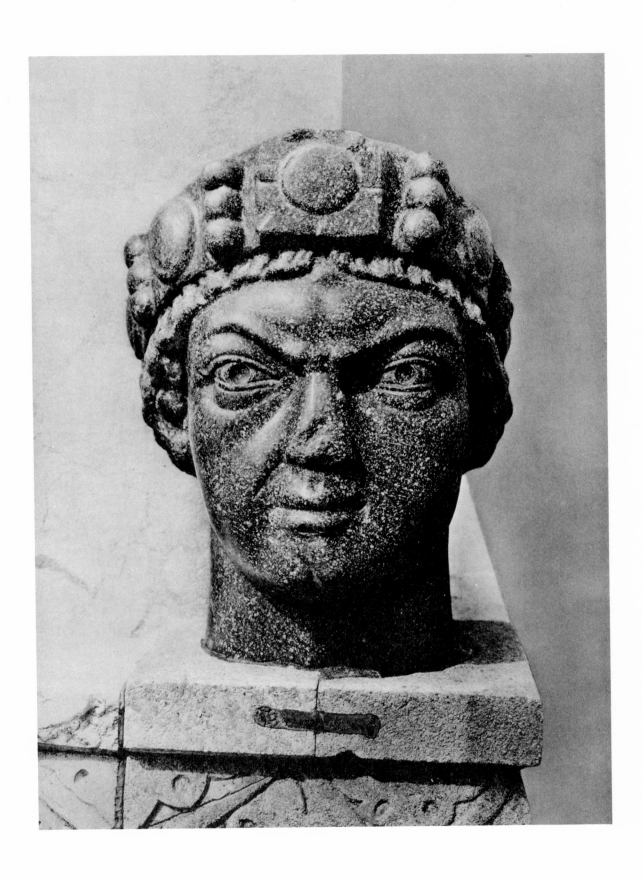

7

VENICE

St. Mark's

So-called " Group of the sons of Constantine "
(Emperor Diocletian and his fellow-rulers?).
Porphyry.

Photo Alinari

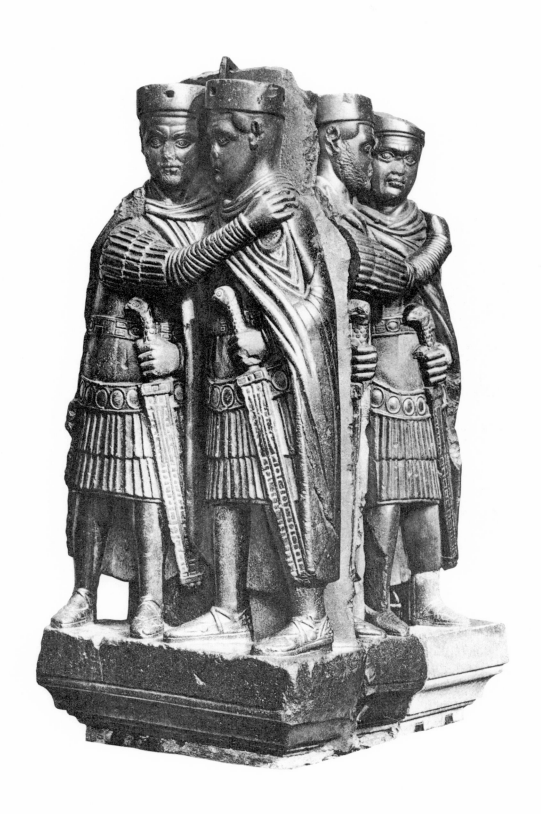

9

ROME

<small>Arch of Constantine</small>

Reliefs from the triumphal Arch of the Emperor Constantine:

<small>A</small>. The victory at the Pons Milvius.
<small>B</small>. The Emperor holding a discourse.

Photo Anderson

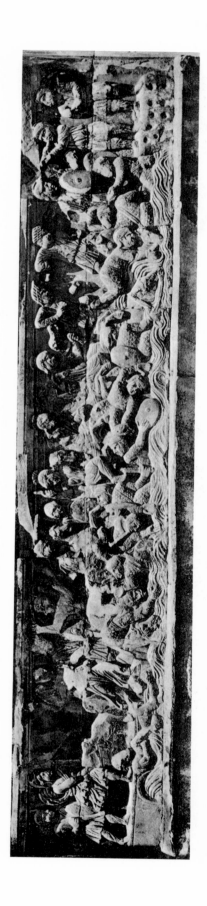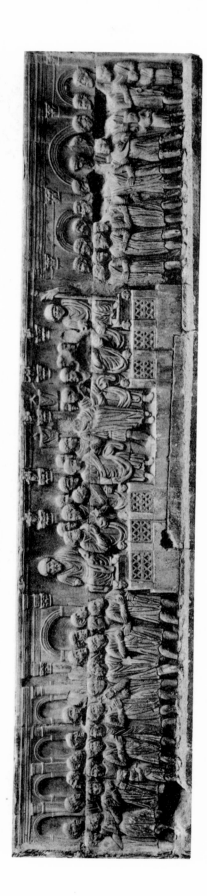

IO

ROME
ARCH OF CONSTANTINE
Relief of a Victory.
Photo Luce

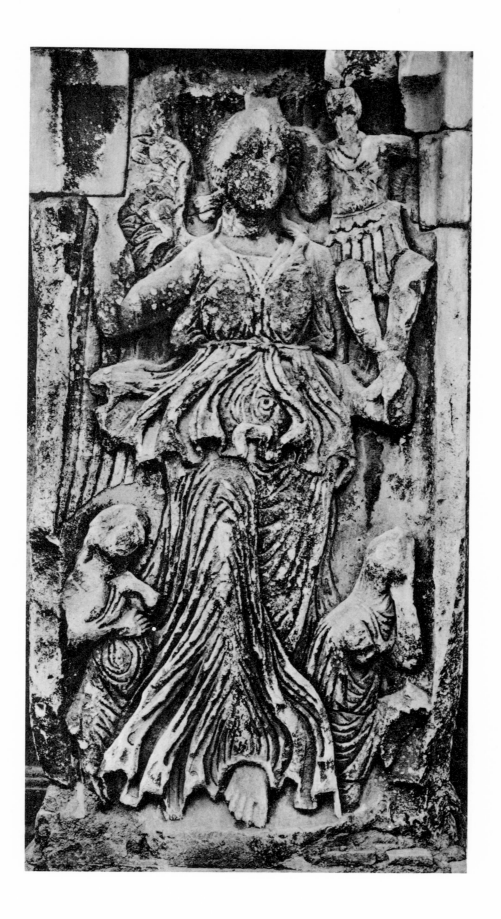

I I

ROME
Museo del Laterano
Early Christian sarcophagus with scenes from the Old and
New Testaments.
Photo Anderson

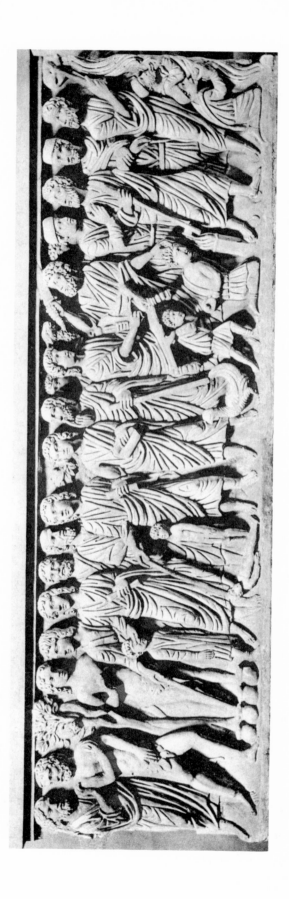

12

ROME

St. Peter's

Sarcophagus of Junius Bassus, prefect of the city, in the
crypt of St. Peter's.

Photo Anderson

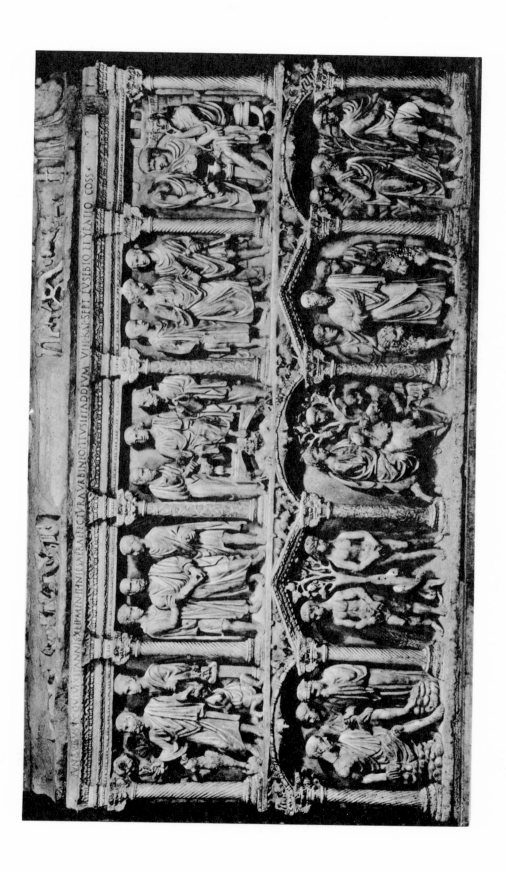

13

ROME
St. Peter's

Christ between the leaders of the Apostles.
Fragment from the sarcophagus of Junius Bassus.
Photo Anderson

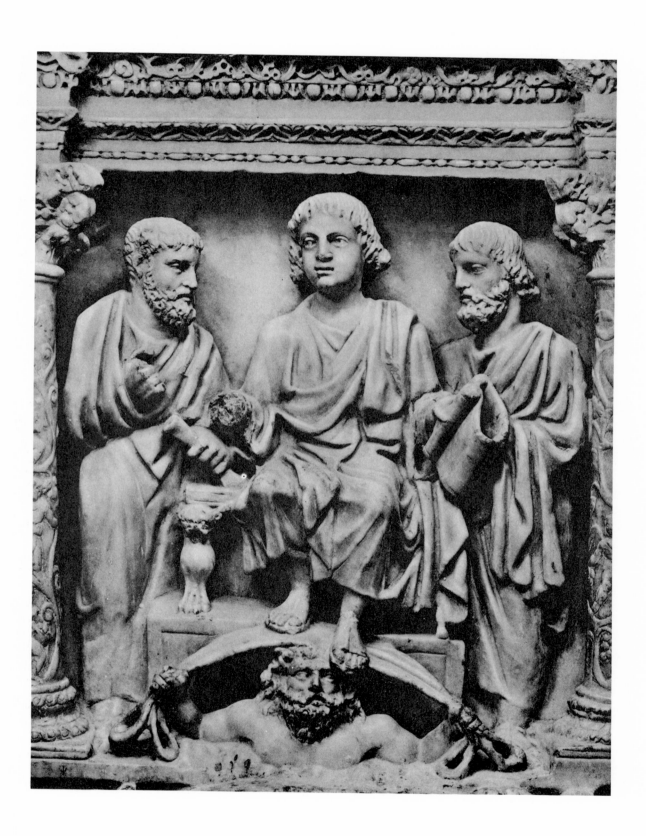

14

ANCONA
CATHEDRAL
Sarcophagus of Gorgonius.
Photo Alinari

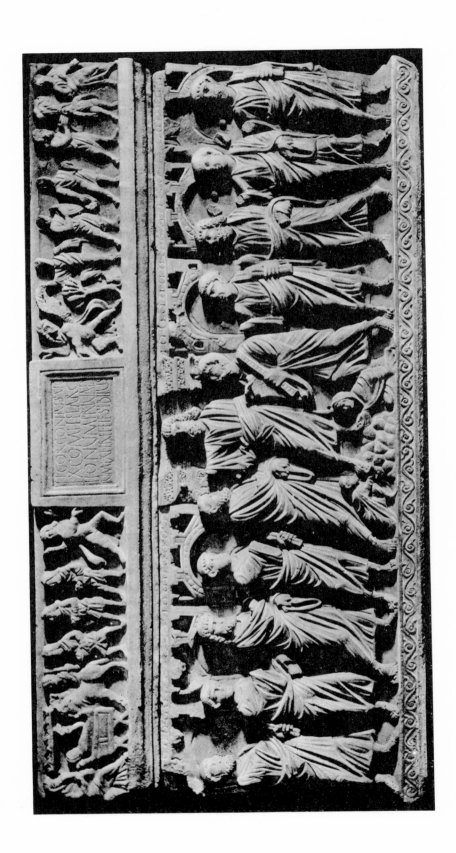

15

MILAN
SANT'AMBROGIO
Side panel of the sarcophagus in Sant'Ambrogio.
Photo Alinari

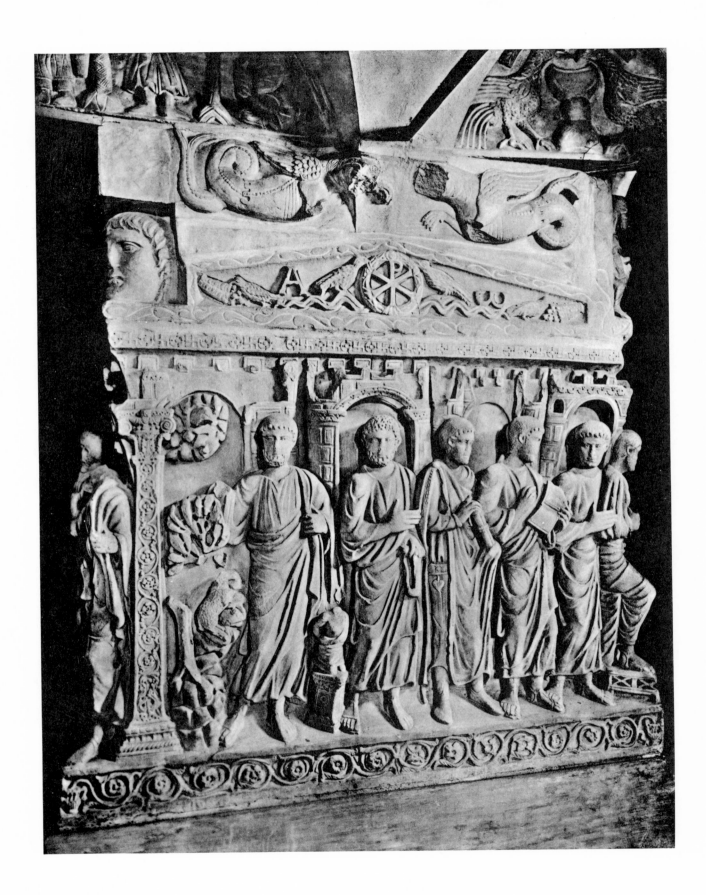

16

A. PARIS
MUSÉE DE CLUNY
Ivory diptych of the Nicomachi and Symmachi.
Photo Giraudon

B. LONDON
VICTORIA & ALBERT MUSEUM
Ivory diptych of the Nicomachi and Symmachi.
Photo Victoria & Albert Museum

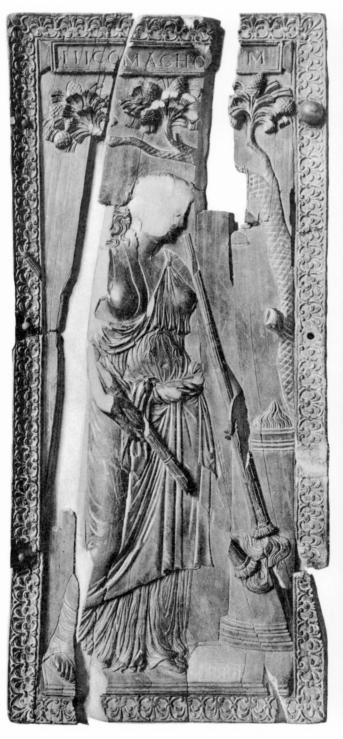

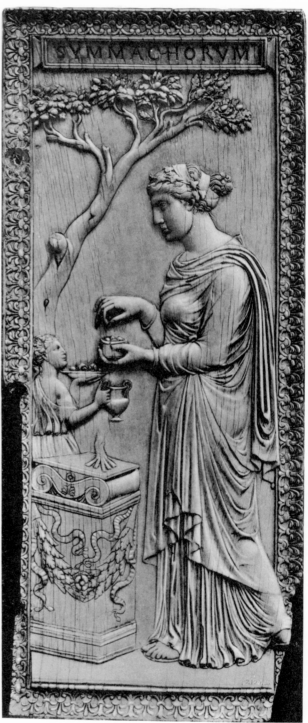

17

BERLIN
Staatsbibliothek
Diptych of the Prefect Probianus.

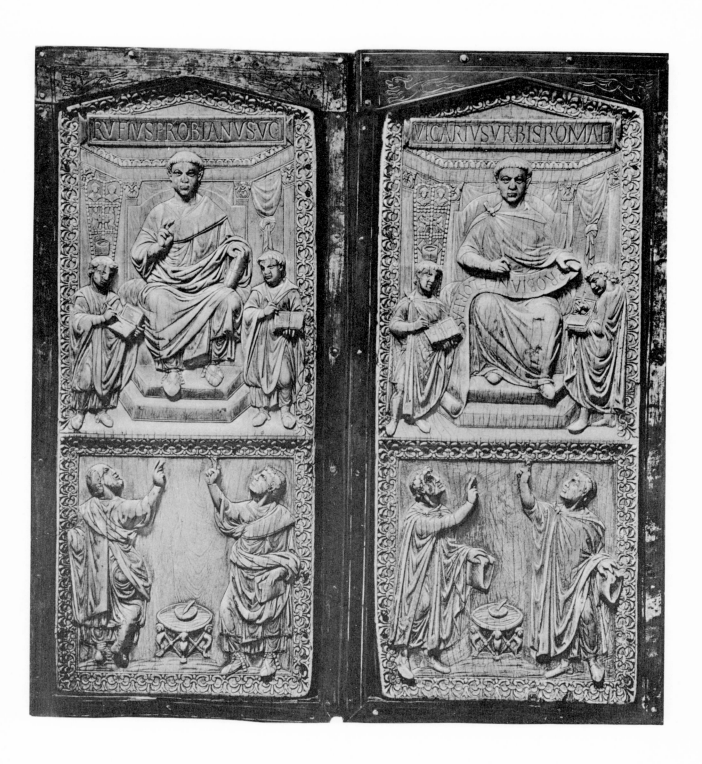

18

MILAN

COLLECTION OF PRINCE TRIVULZIO

Ivory tablet showing the Holy Women at the Tomb,
half of a diptych.

Photo Rossi

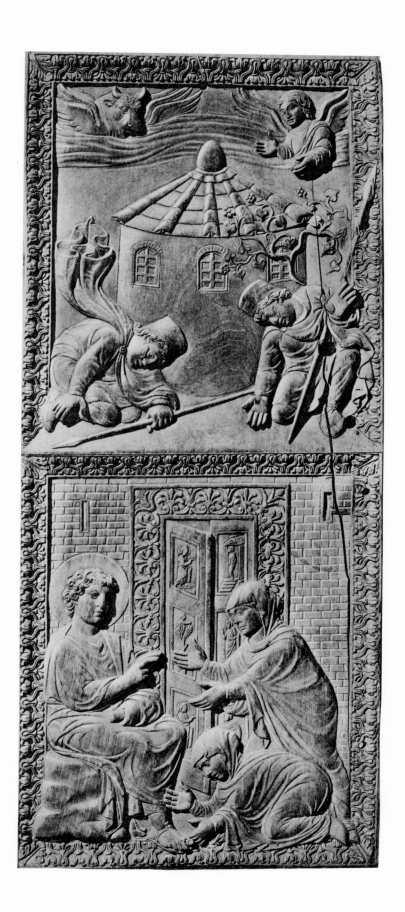

19

MUNICH

NATIONALMUSEUM

Ivory tablet showing the Holy Women at the Tomb, and the
Ascension of Christ (the so-called Von Reider tablet).

Photo Nationalmuseum, Munich

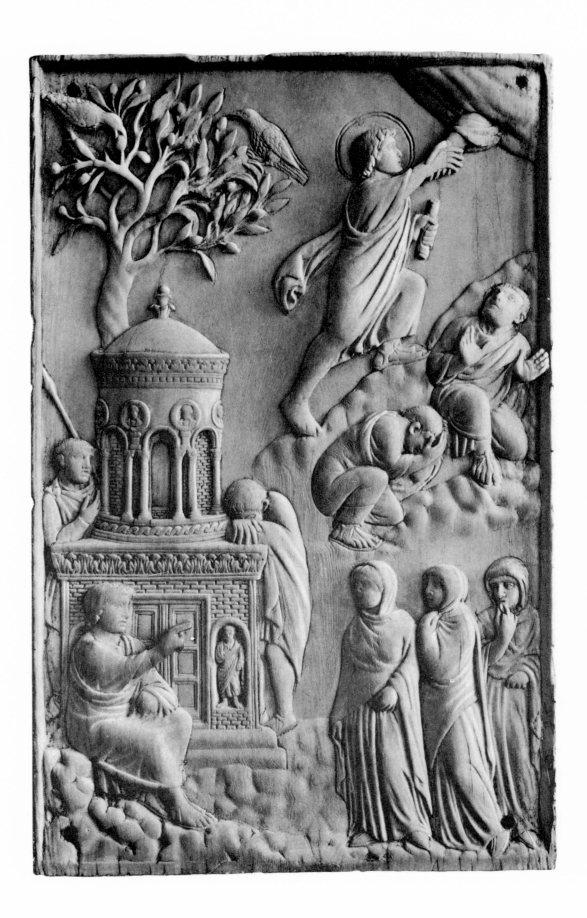

20

BRESCIA
Museo Civico
Diptych of Boethius.
Photo Alinari

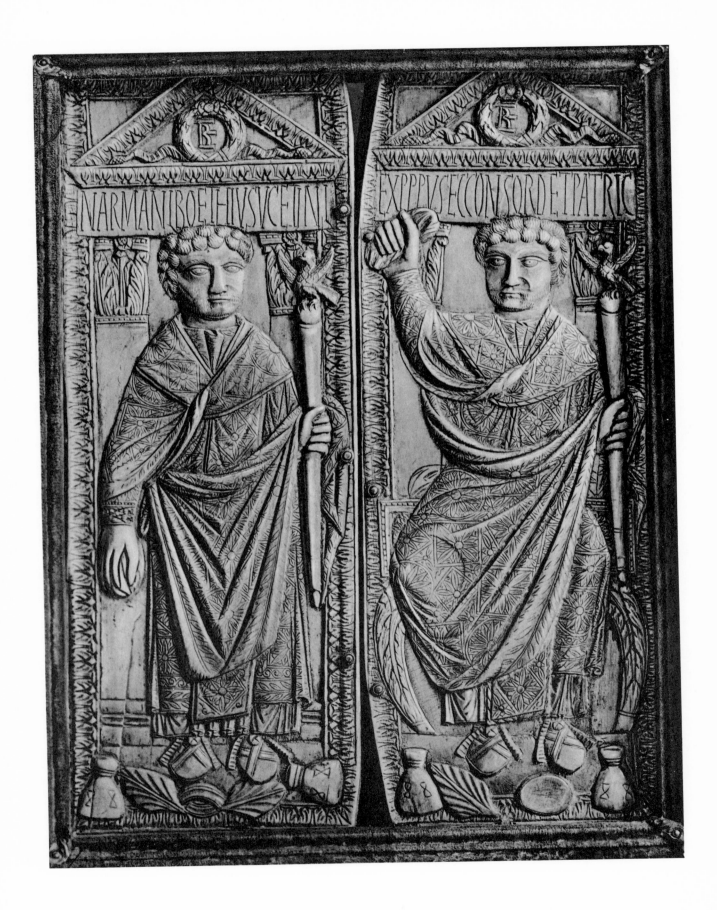

21

MILAN
TREASURY OF THE CATHEDRAL
Diptych in five parts showing scenes from the Life of Christ
down to the Entry into Jerusalem.
Photo Ferrario

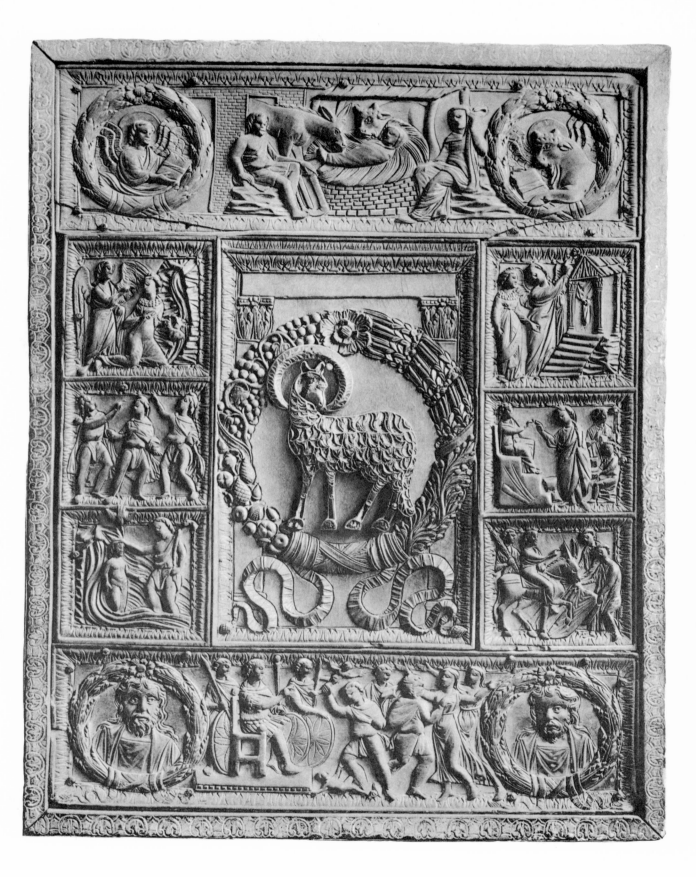

22

ROME
Santa Sabina

Relief of the Ascension of Elijah, from the wooden door of the
church of Santa Sabina.

Photo Alinari

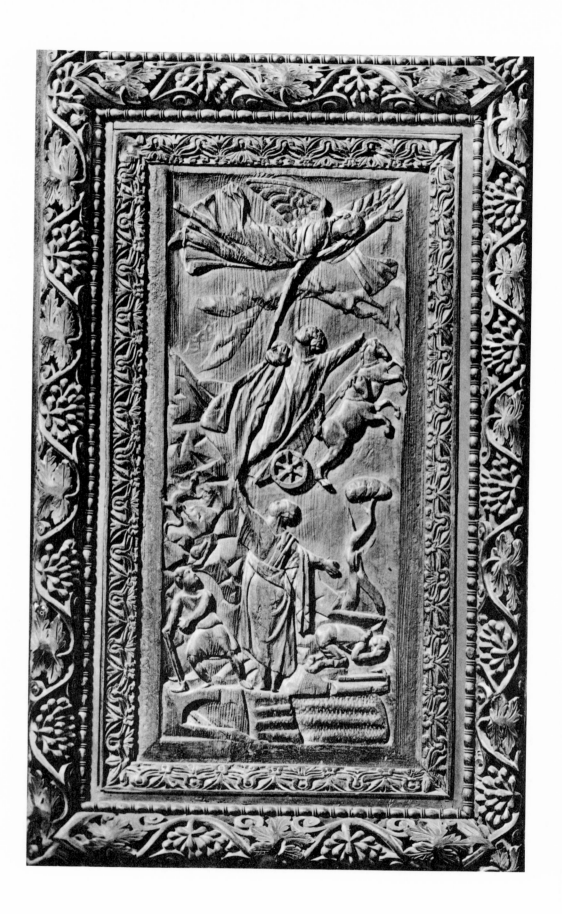

23

SPOLETO

The church of San Salvatore or Il Crocefisso, near Spoleto.
Photo Anderson

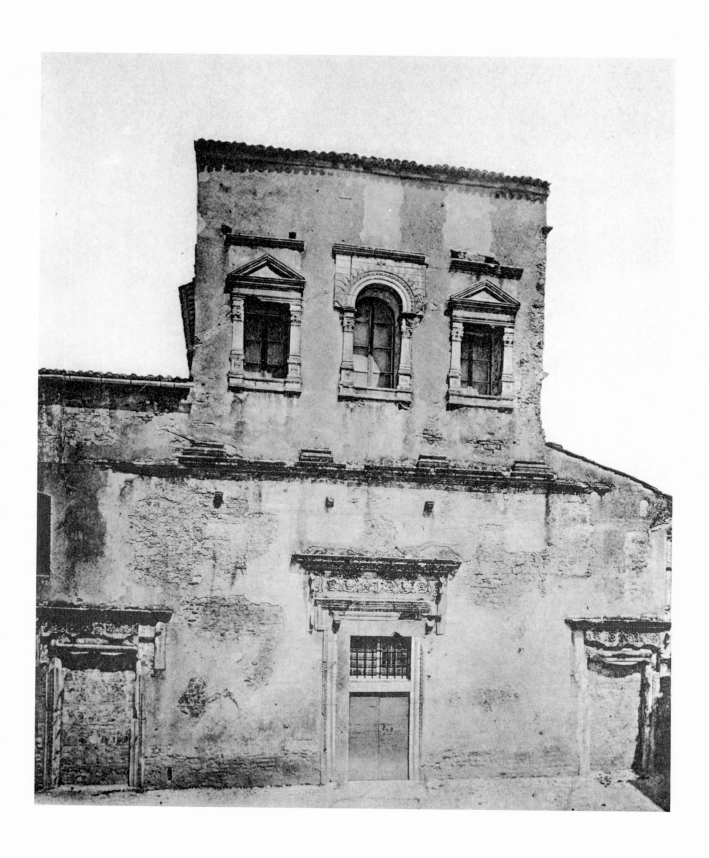

24

SPOLETO

Two fragments from the framework of the doorway in the
church of San Salvatore.

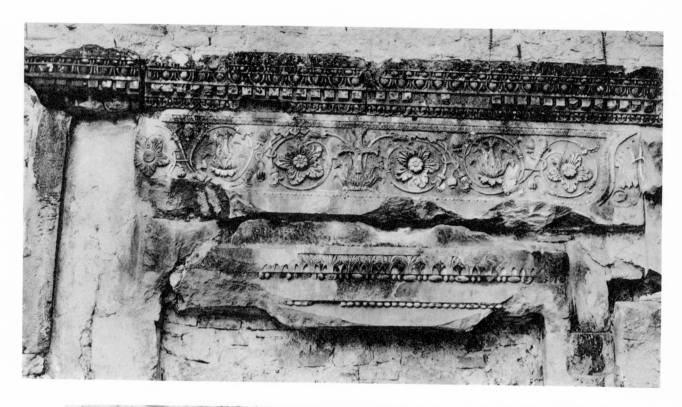

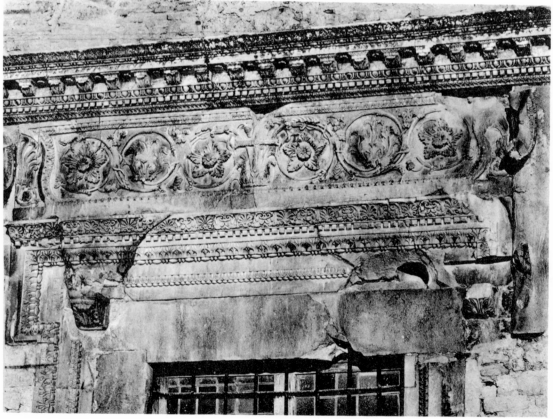

25

TREVI
The Clitumnus Temple near Trevi.
Photo Benvenuti

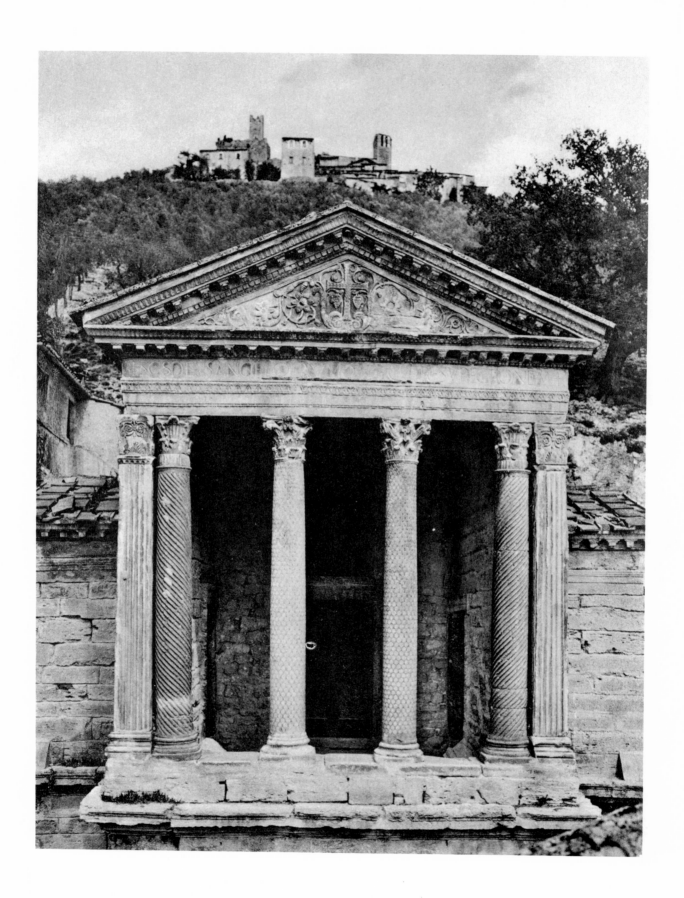

26

TREVI

The Clitumnus Temple. Apse.
Photo Kunsthistorisches Institut, Kiel

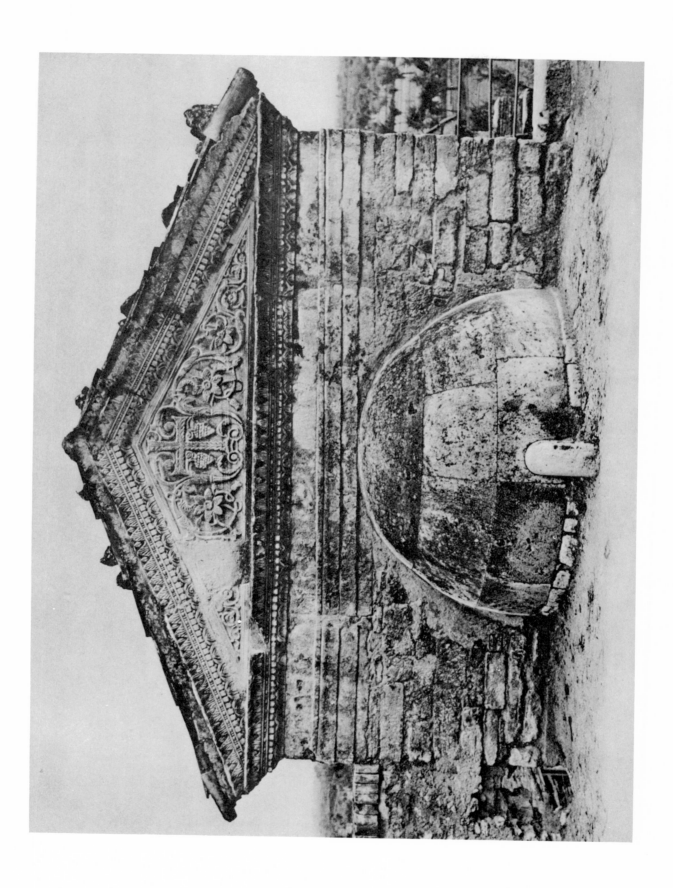

27

TREVI

The Clitumnus Temple.
A niche of the altar.

Photo Anderson

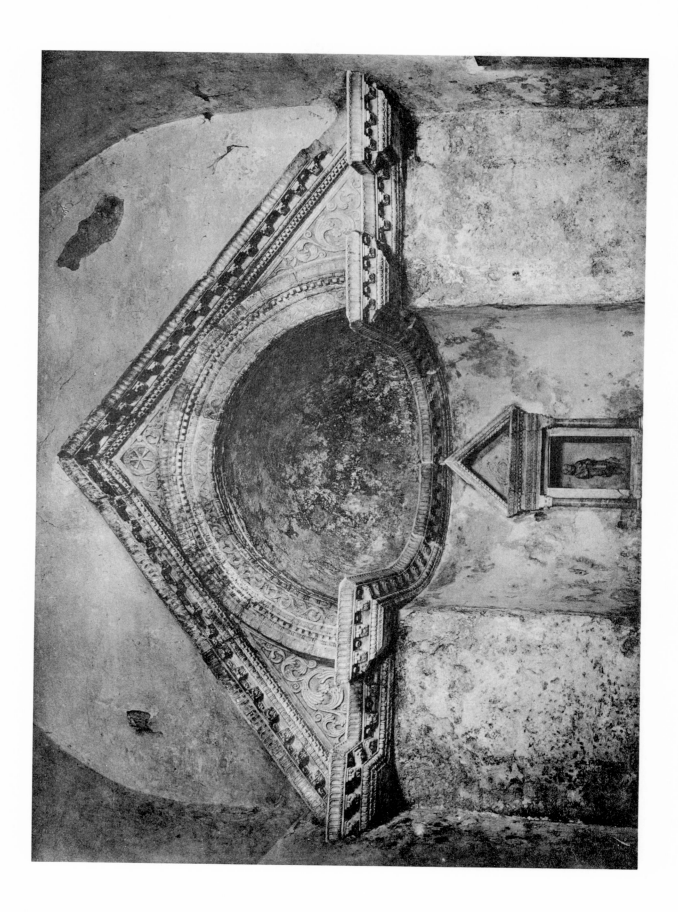

28

RAVENNA
BATTISTERIO DEGLI ORTODOSSI
Stucco decoration.
Photo Ricci

29

RAVENNA
SAN FRANCESCO
Sarcophagus of Archbishop Liberius.
Photo Alinari

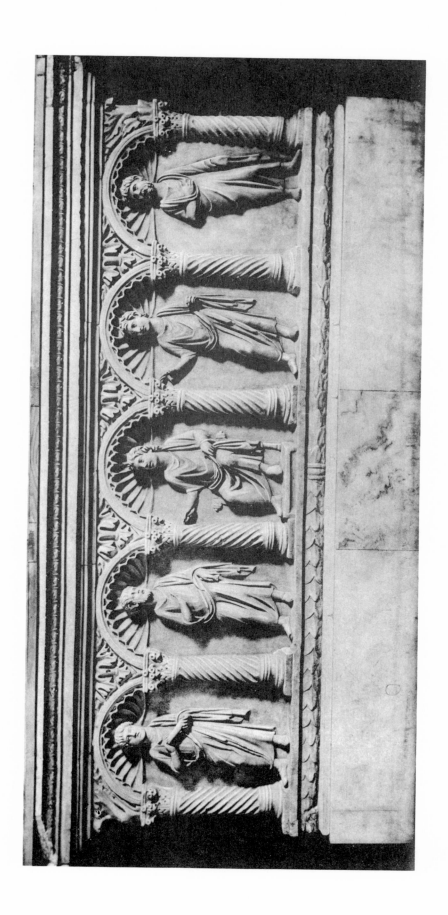

30

RAVENNA
Sepolcreto di Braccioforte
Sarcophagus of the Prophet Elisha (Pignatta Sarcophagus).
Photo Ricci

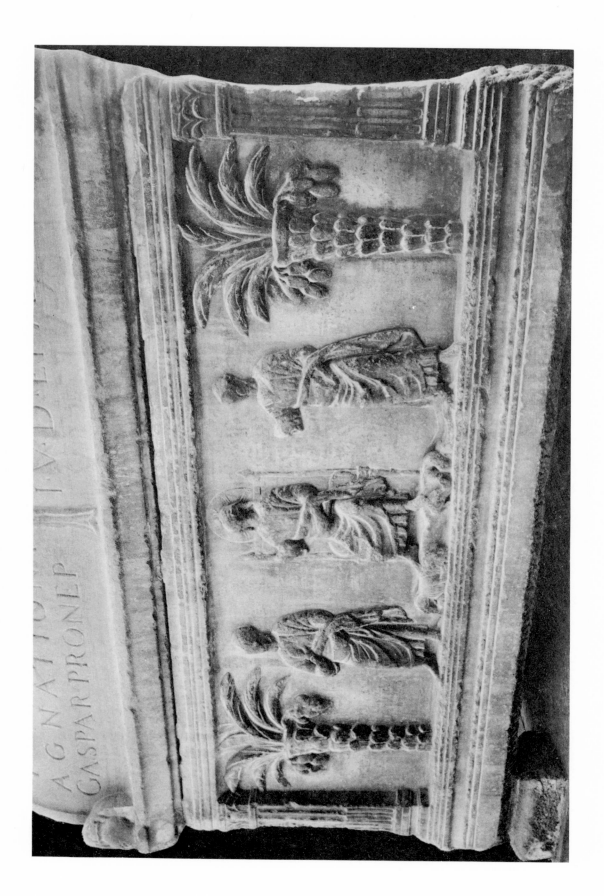

31

RAVENNA
Sᴇᴘᴏʟᴄʀᴇᴛᴏ ᴅɪ Bʀᴀᴄᴄɪᴏғᴏʀᴛᴇ
Back of the Elisha Sarcophagus.
Photo Ricci

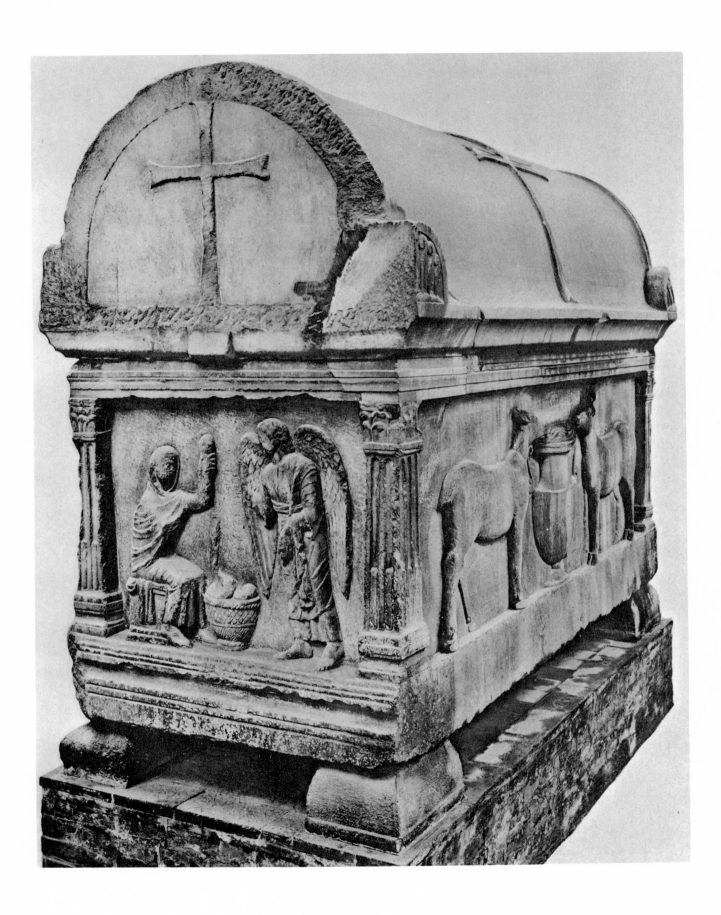

32

RAVENNA
SANT'APOLLINARE IN CLASSE
Sarcophagus with representation of Christ and the 12 Apostles.
Photo Alinari

33

RAVENNA
SANT'APOLLINARE IN CLASSE
Ends of the Apostle Sarcophagus and the
Theodore Sarcophagus.
Photo Alinari

34

RAVENNA
SANT'APOLLINARE IN CLASSE
Sarcophagus of Archbishop Theodore.
Photo Anderson

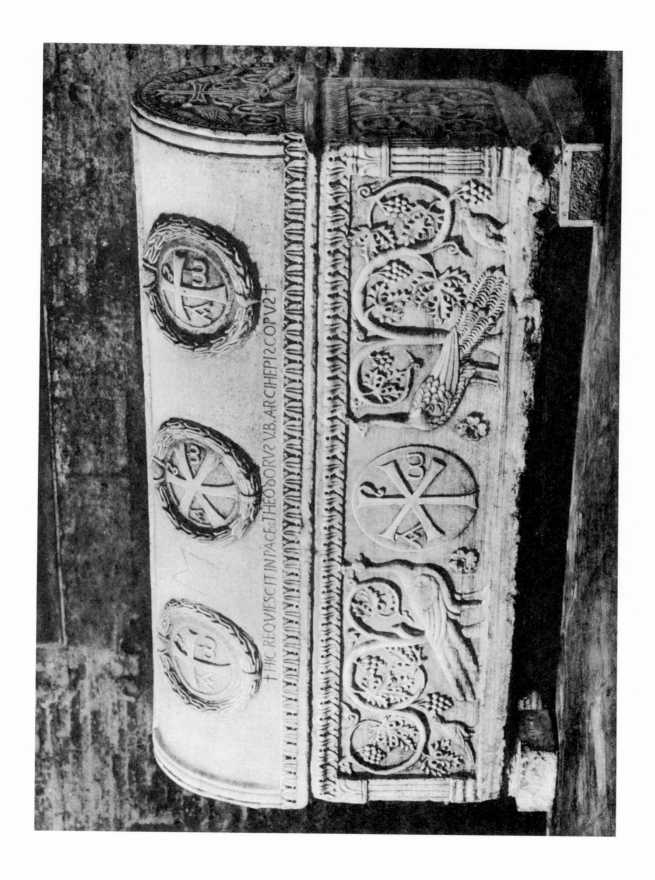

35

RAVENNA

A. SAN VITALE
Choir-screen panel.
Photo Alinari

B. CATHEDRAL
Choir-screen panel.
Photo Poppi

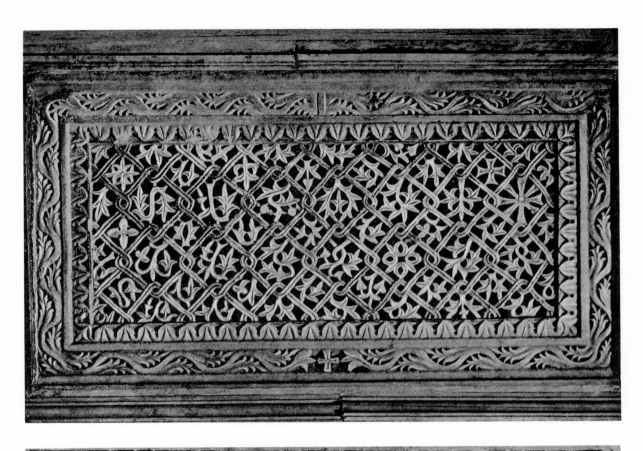

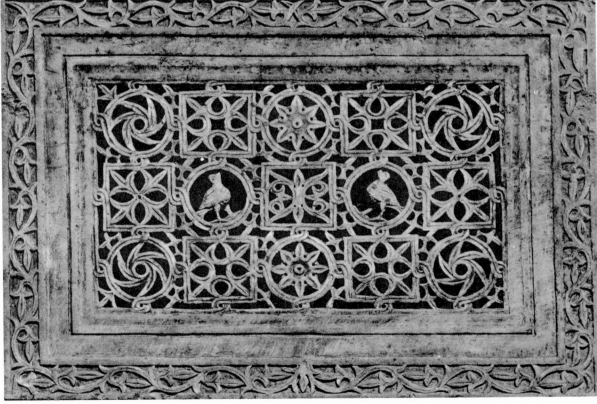

36

RAVENNA
Sant'Apollinare Nuovo
Choir-screen panel.
Photo Anderson

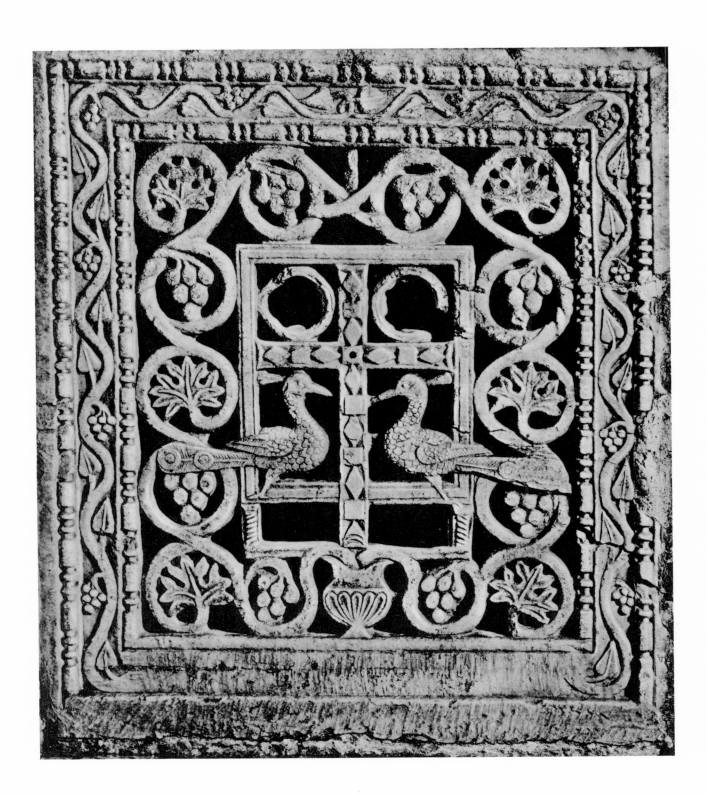

37

RAVENNA

A. SAN VITALE — B. SANT'AGATA

Panel of the altar. Panel of the altar.

Photo Anderson

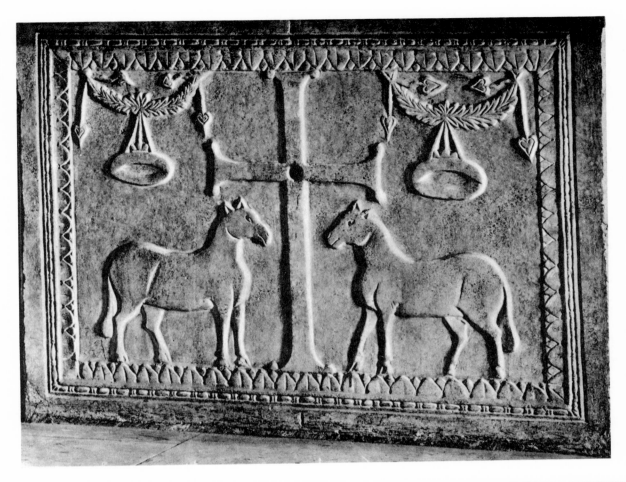

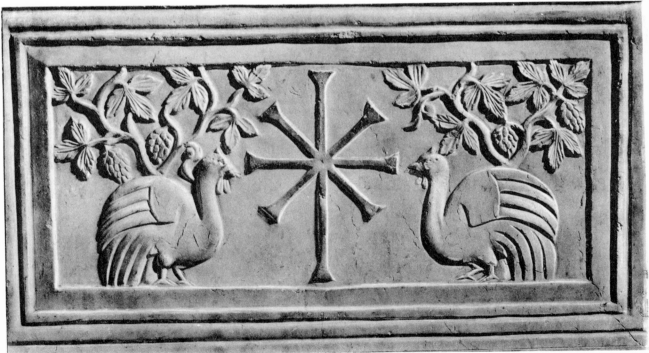

38

RAVENNA
SAN VITALE
Capital.
Photo Alinari

39

RAVENNA
CATHEDRAL
Pulpit of Archbishop Agnellus.
Photo Anderson

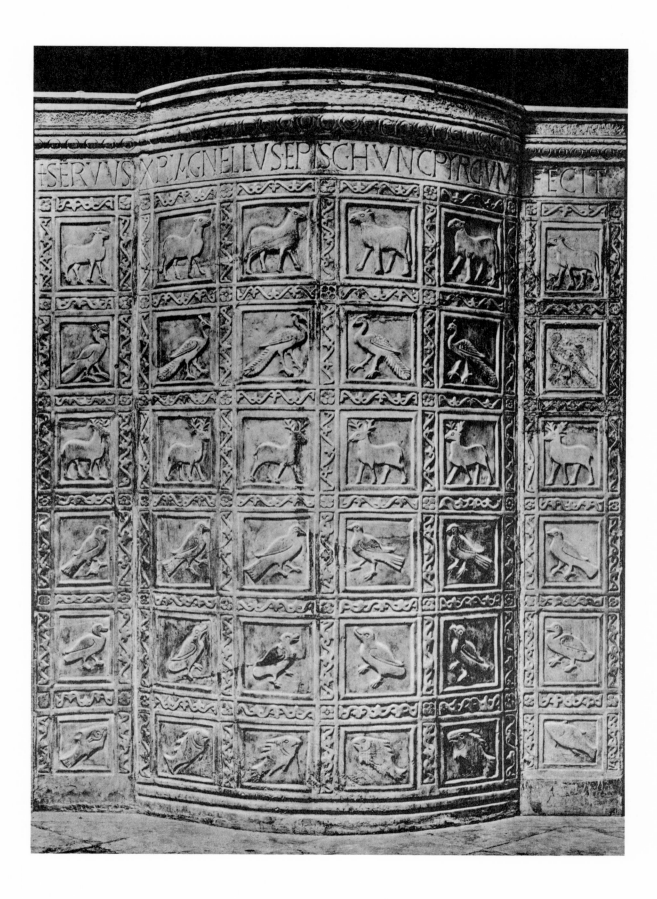

40

RAVENNA
A. SAN VITALE
Sarcophagus of St. Ecclesius.
Photo Anderson

B. SANT'APOLLINARE IN CLASSE
Sarcophagus of St. Felix.
Photo Anderson

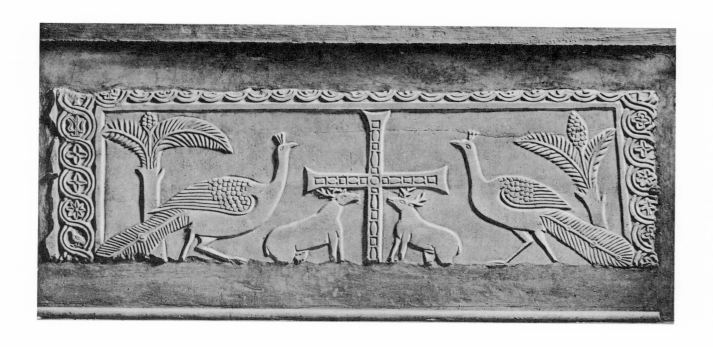

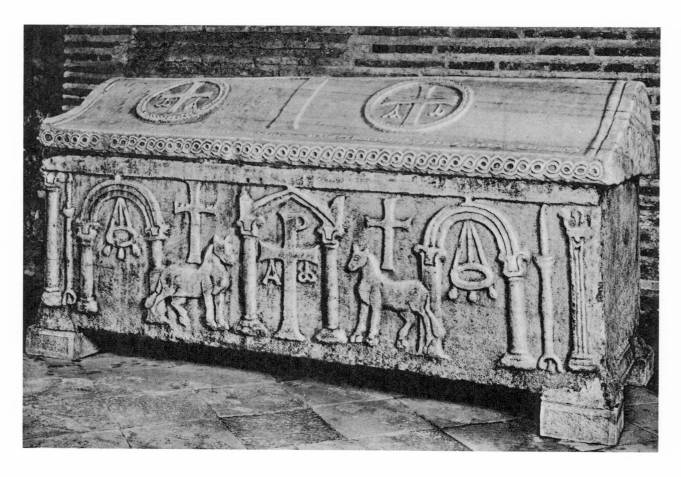

41

LONDON
Victoria & Albert Museum
Diptych of the Consul Orestes.
Photo Victoria & Albert Museum

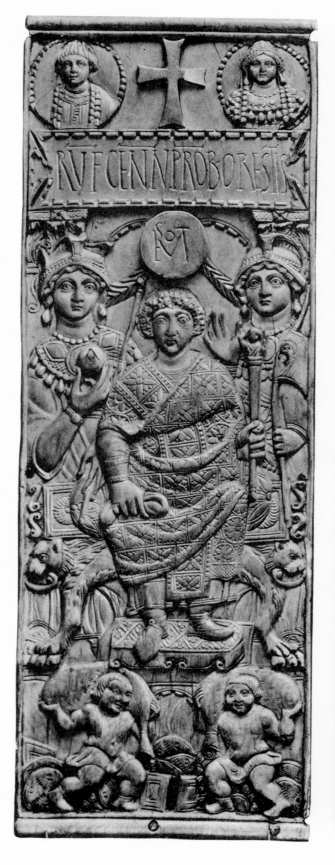

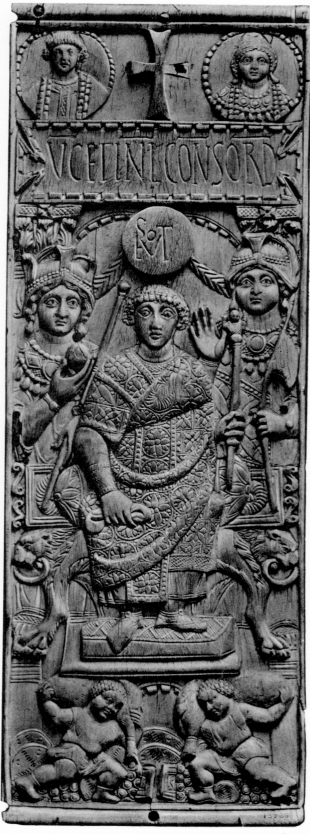

42

ROME
SAN CLEMENTE
A. Choir-screen panel with tracery-work.
Photo Alinari

B. Choir-screen panel with the monogram of Pope John II.
Photo Moscioni

43

FLORENCE
Bargello
Gilded decorative plate of a Lombard helmet, with a
representation of King Agilulf.
Photo Alinari

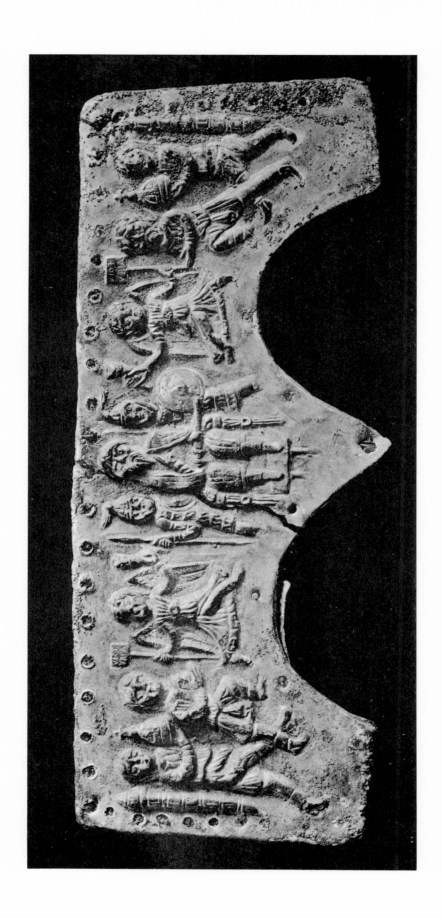

44

PAVIA
Museo Civico
Panels from the sarcophagus of Theodota.
Photo Alinari

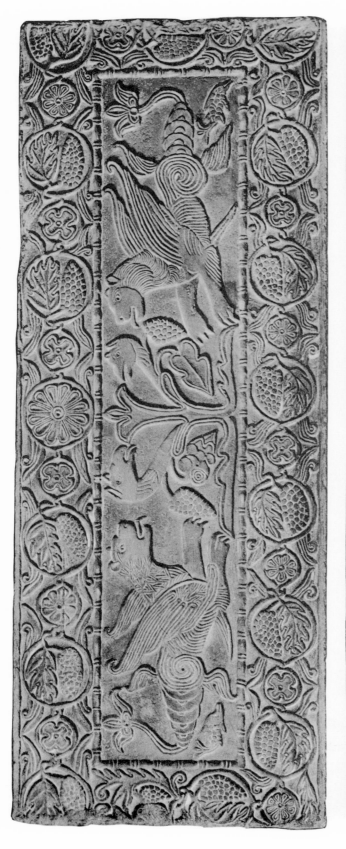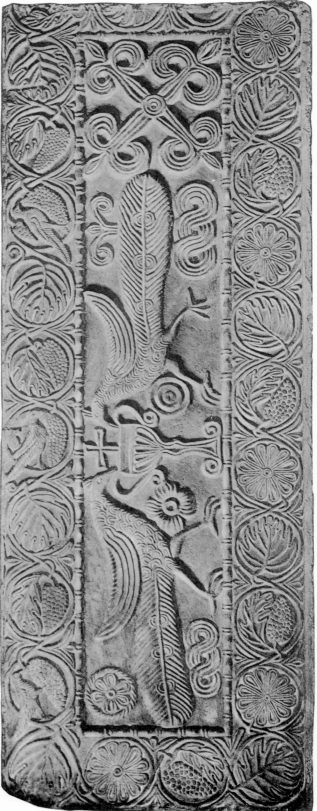

45

CIVIDALE
San Martino
Side panels of the altar of Duke Ratchis.

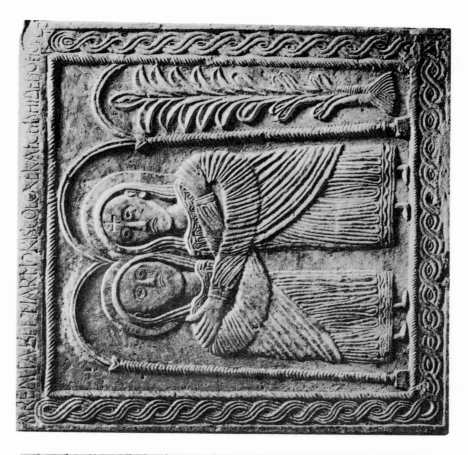

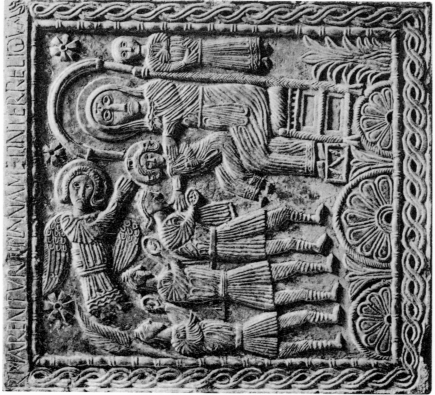

46

CIVIDALE
CATHEDRAL
Panel from the altar of the Patriarch Sigvald.
Photo O. Böhm

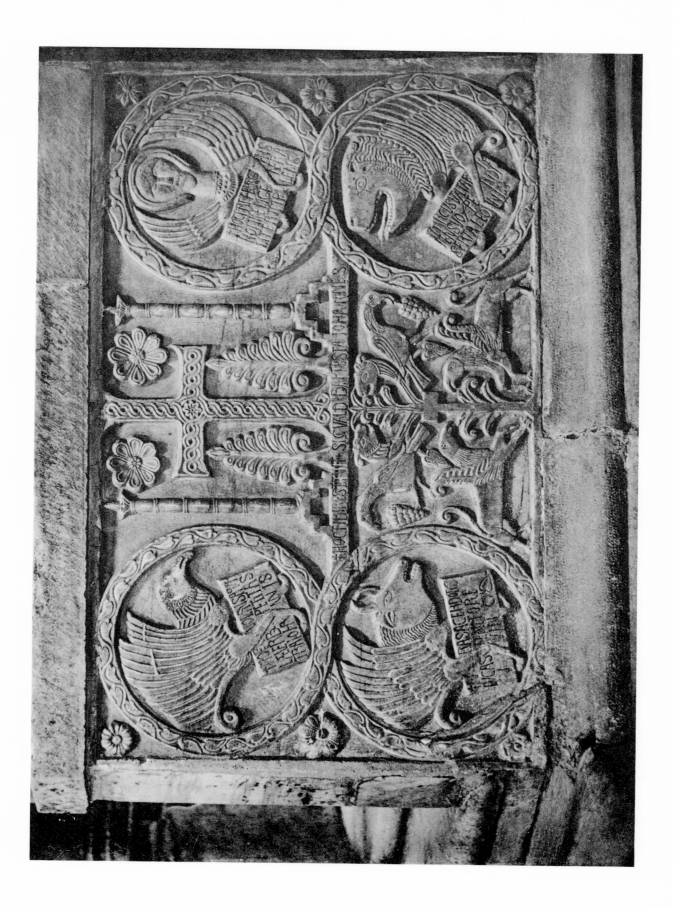

47

CIVIDALE
CATHEDRAL

Fragments of panels on the Baptistery.
Photo O. Böhm

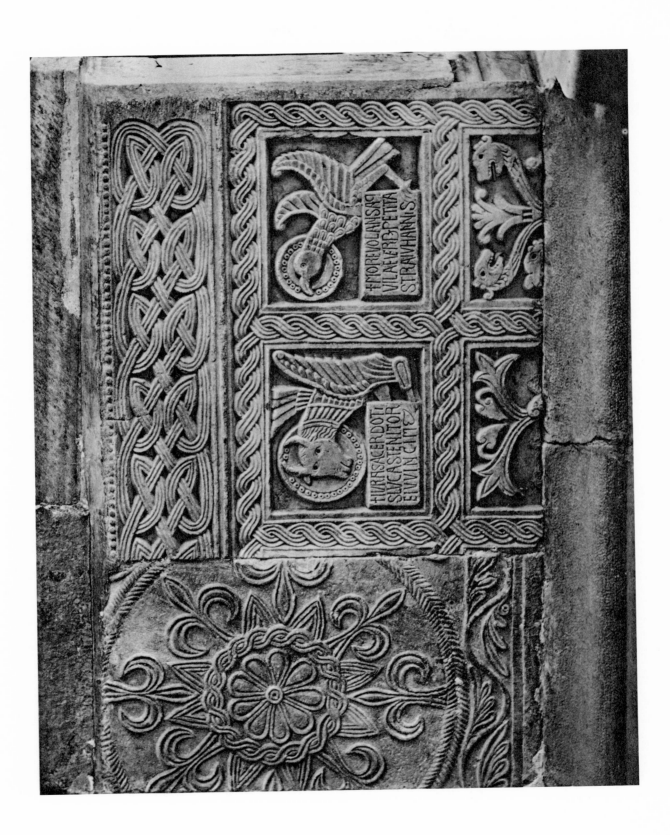

48

CIVIDALE
Santa Maria in Valle
Entrance-wall of the church.
Photo Luce

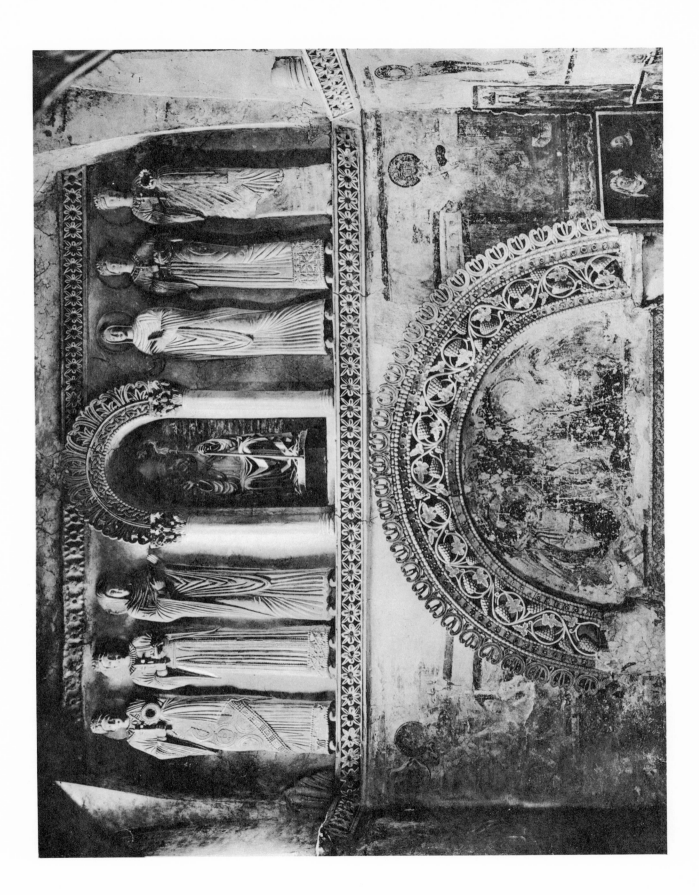

49

CIVIDALE
SANTA MARIA IN VALLE
Lunette of the portal.
Photo Luce

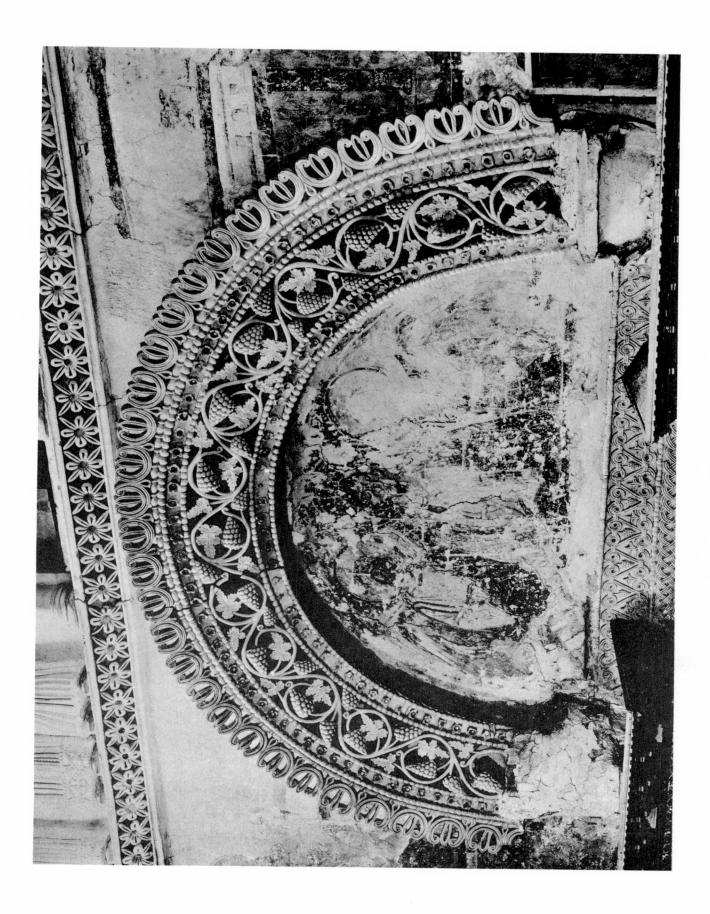

50

CIVIDALE
Santa Maria in Valle
Frieze with figures.
Photo Luce

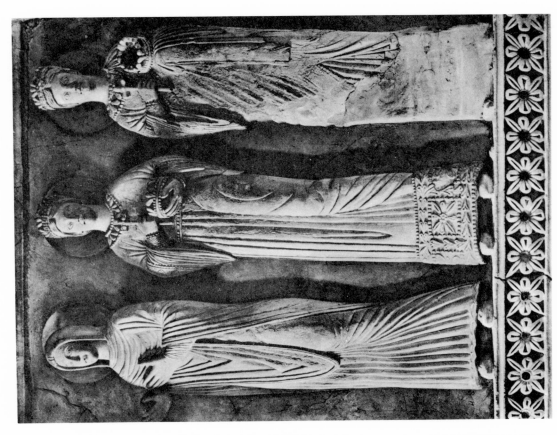

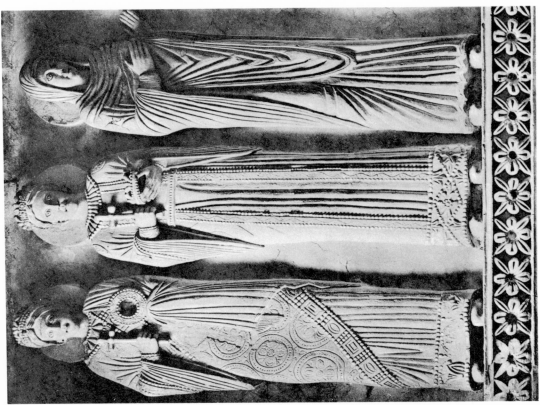

51

CIVIDALE
Santa Maria in Valle

Fragments of a ciborium and a choir-screen panel.
Photo Luce

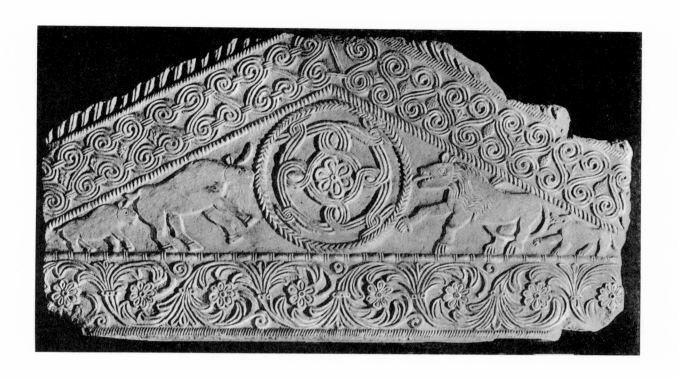

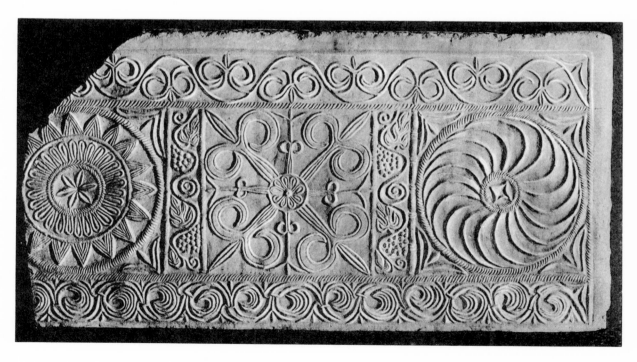

52

FERRARA

UNIVERSITY

Pulpit panels from Voghenza.

Photo Kunsthistorisches Institut, Kiel

53

RAVENNA
SANT'APOLLINARE IN CLASSE
Archivolt from the ciborium of St. Eleucadius.
Photo Ricci

54

FERENTILLO
Abbey Church of San Pietro
Relief panel by Master Ursus.
Photo Luce

55

SPOLETO
SAN GREGORIO
Relief panel.
Photo Luce

56

A. ROME
SAN SABA
Relief panel with hunting-scene.
Photo Alinari

B. CIVITA CASTELLANA
CATHEDRAL
Relief panel with hunting-scenes.
Photo Alinari

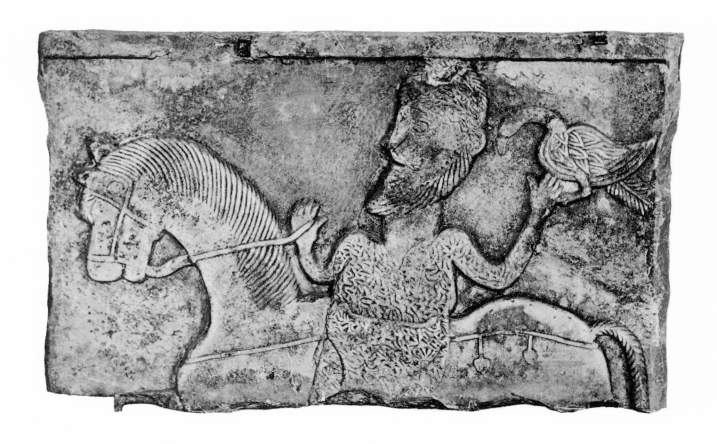

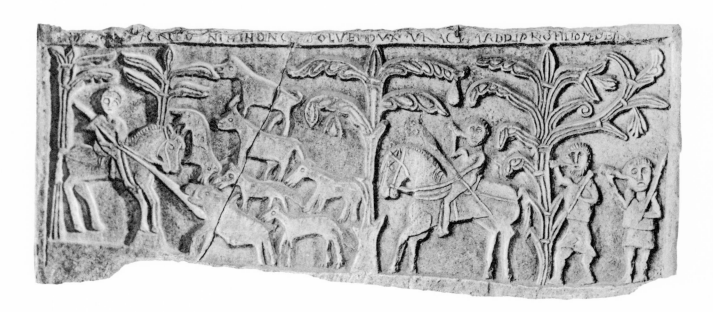

57

ROME

VATICAN MUSEUM

Silver container of the golden bejewelled cross from the treasury
of the Cappella Sancta Sanctorum.

Photo Sansaini

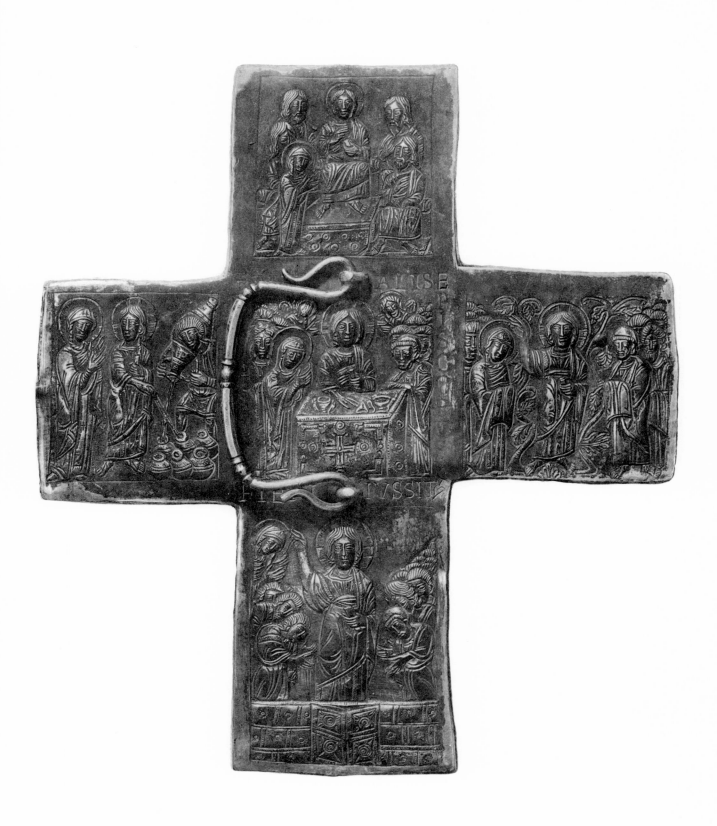

58

ROME

VATICAN MUSEUM

Lid of the silver container of the enamelled cross from the
treasury of the Cappella Sancta Sanctorum.

Photo Sansaini

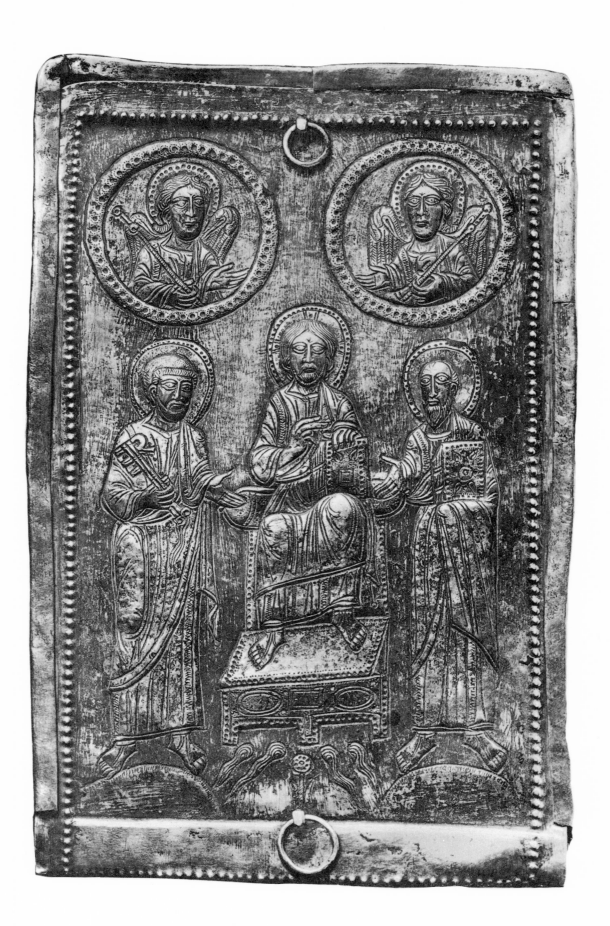

59

ROME
SANTA MARIA IN AVENTINO
Altar panels.
Photo Kunsthistorisches Institut, Kiel

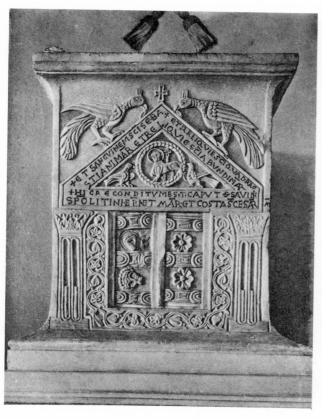
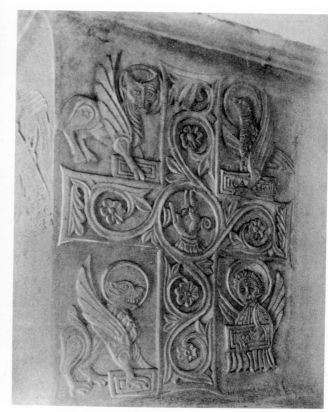

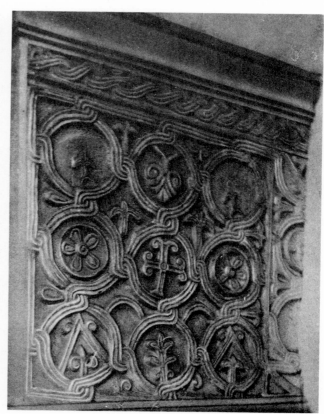

60

ROME
SANTA SABINA
Choir-screen panel.
Photo Anderson

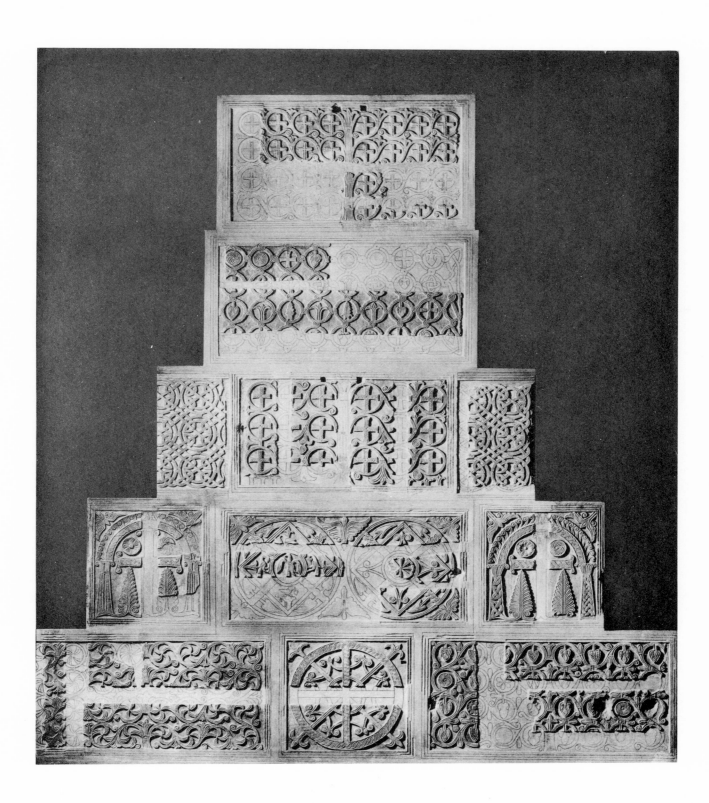

61

ROME
SANTA MARIA IN TRASTEVERE
Choir-screen panel.
Photo Alinari

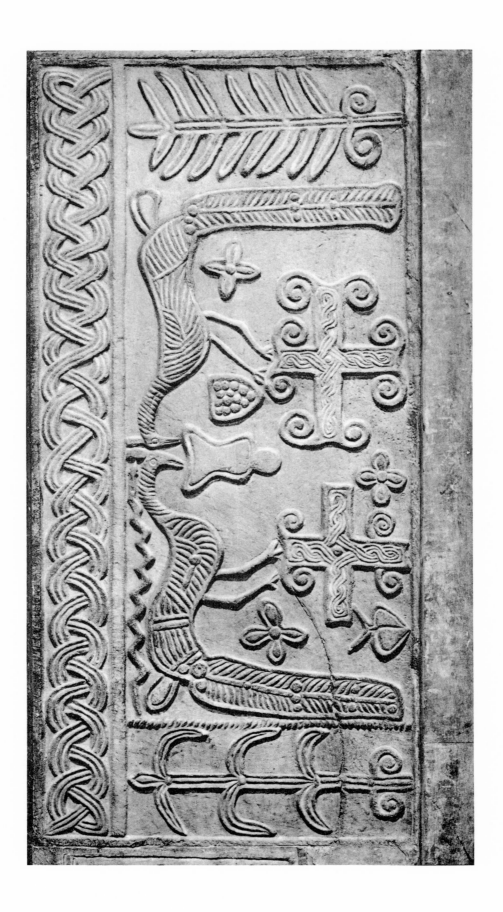

62

CALVI
CATHEDRAL
Sarcophagus in the wall of the cathedral.
Photo Kunsthistorisches Institut, Kiel

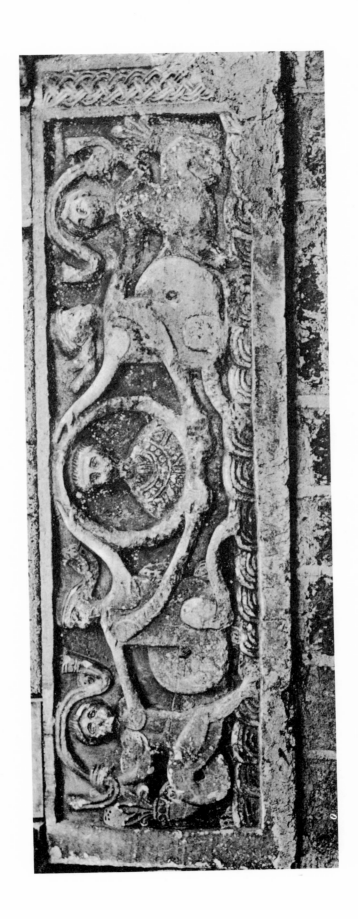

63

CAPUA
SAN GIOVANNI A CORTE
Relief.
Photo Kunsthistorisches Institut, Kiel

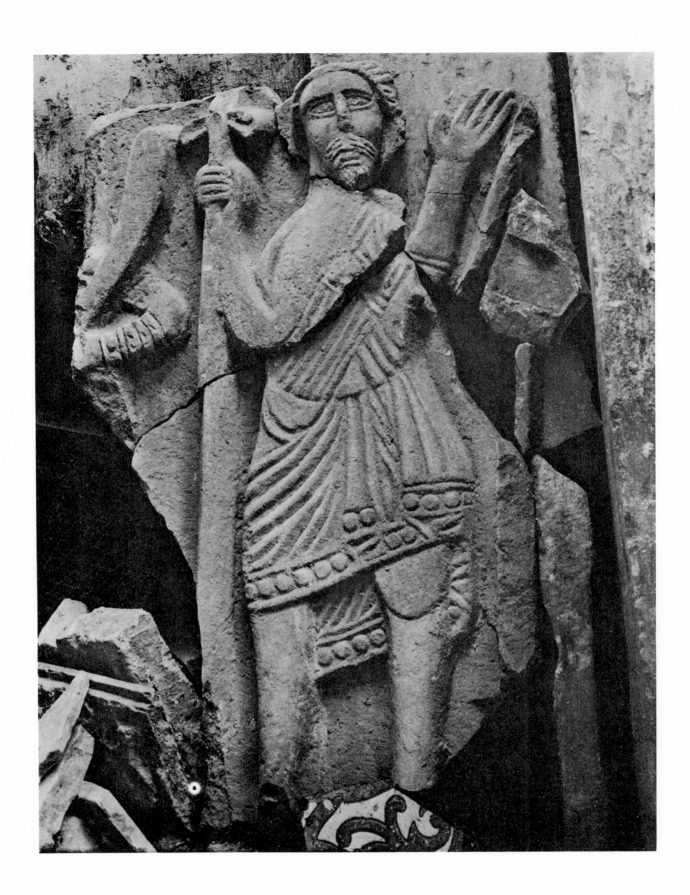

64

CIMITILE
Relief panel in the church of Cimitile.
Photo Kunsthistorisches Institut, Kiel

65

NAPLES
PALAZZO ARCIVESCOVILE
Calendar reliefs.
Photo Kunsthistorisches Institut, Kiel

66

NAPLES
San Giovanni Maggiore
Part of a relief panel.
Photo Kunsthistorisches Institut, Kiel

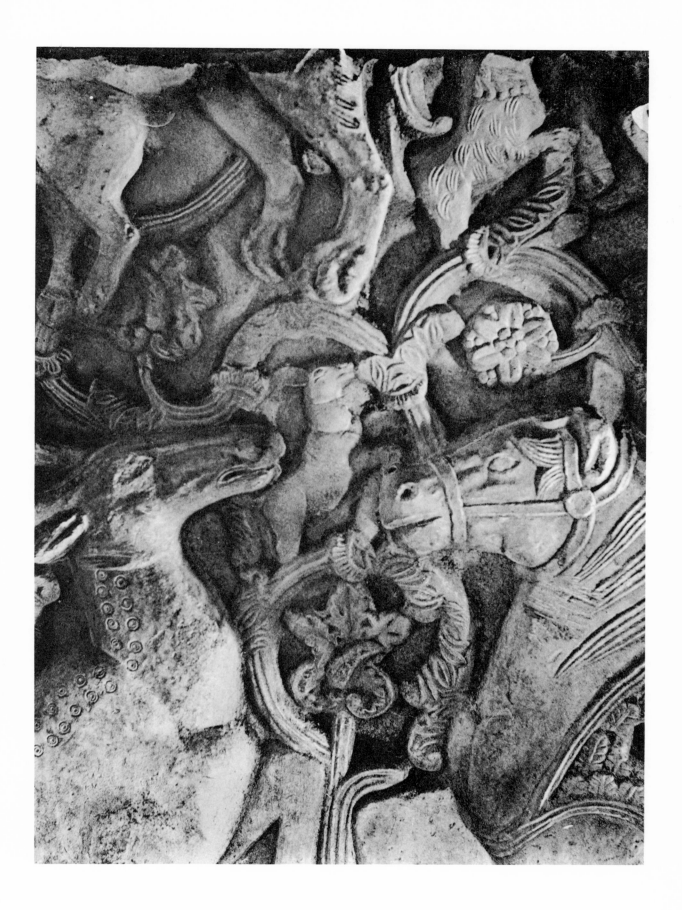

67

A. SORRENTO
Museo Civico
Relief panel.

B. ROME
Baracco Museum
Relief panel.

Photo Kunsthistorisches Institut, Kiel

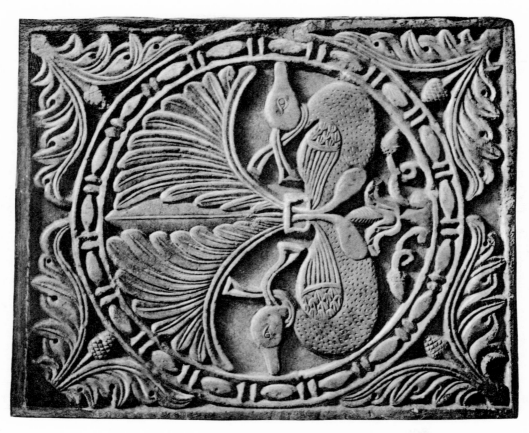
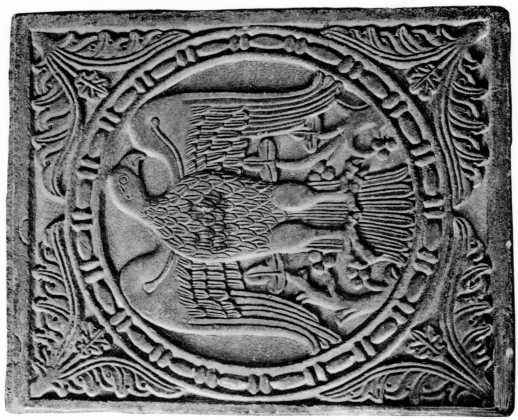

68

SORRENTO
Museo Civico
Choir-screen panels.
Photo Kunsthistorisches Institut, Kiel

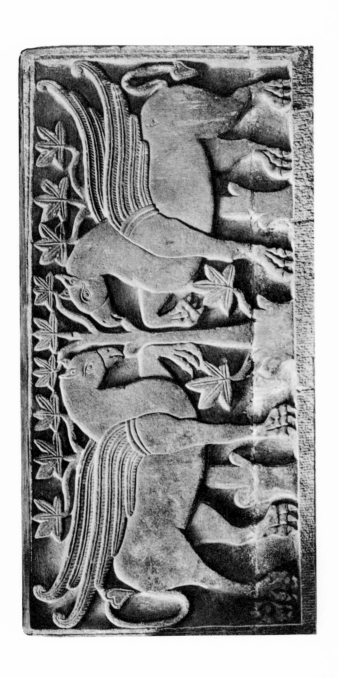

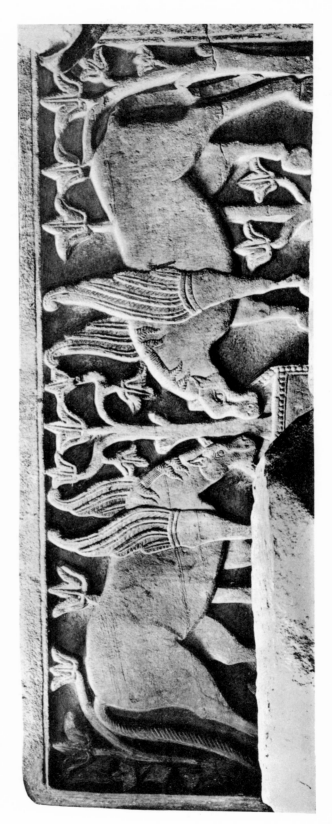

69

TRAETTO-MINTURNO
Relief panel on the pulpit, with a representation of Jonah.
Photo Kunsthistorisches Institut, Kiel

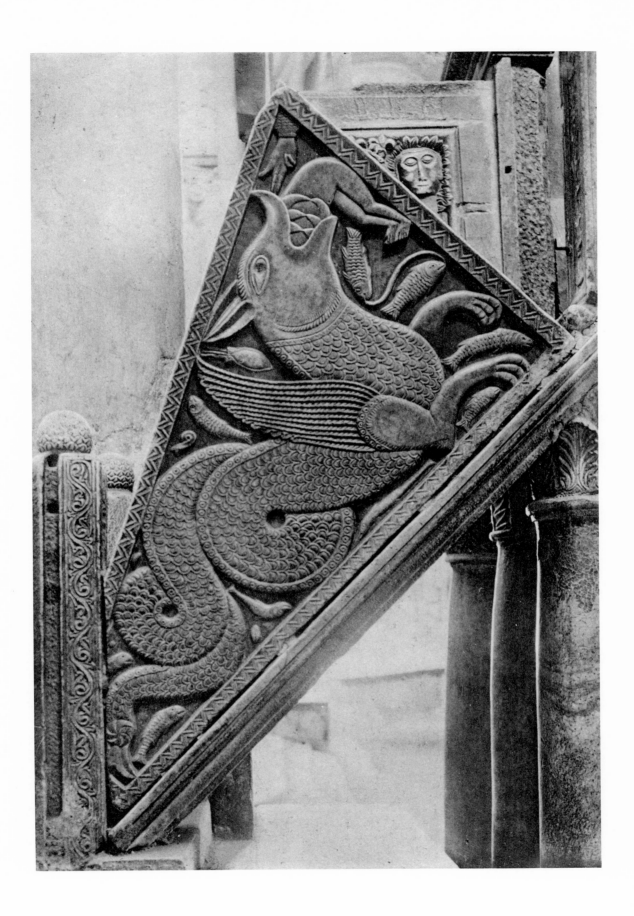

70

A. ATRANI
San Salvatore
Relief panel with representations of peacocks.

B. VENICE
St. Mark's
Relief panel with representations of peacocks.
Photo Alinari

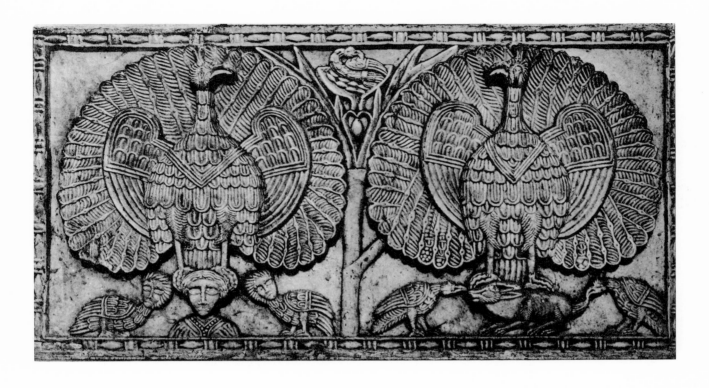

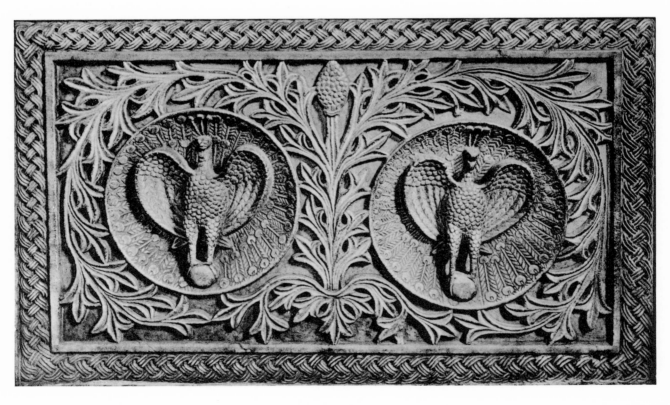

71

MILAN
SANT'AMBROGIO
Sides of the antependium of the altar of Archbishop Angilbert.
Photo Alinari

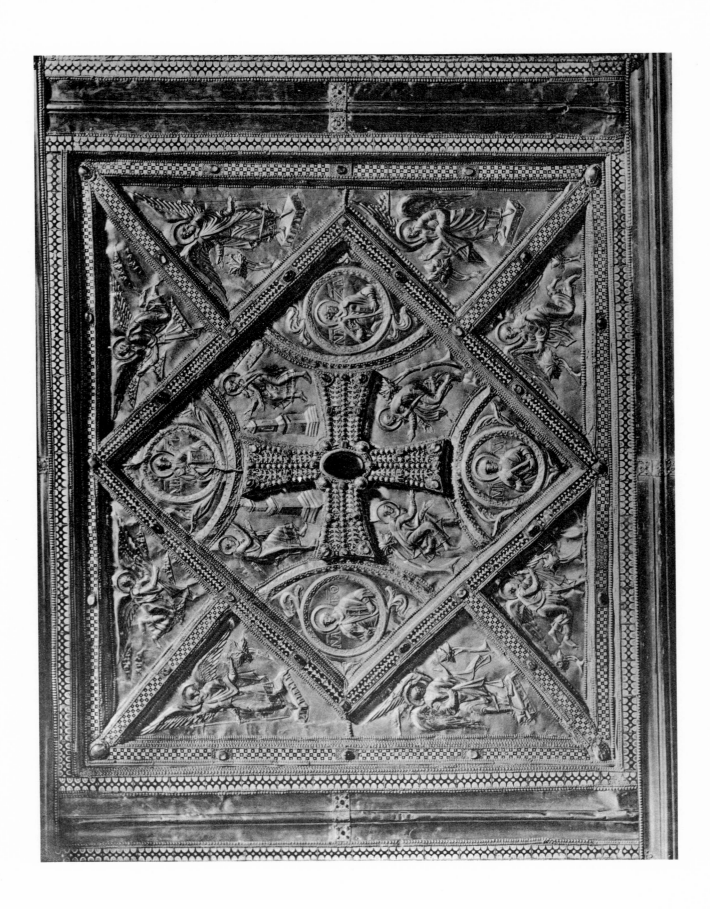

72

MILAN
Sant'Ambrogio
Part of the back of the Angilbert antependium.
Photo Ferrario

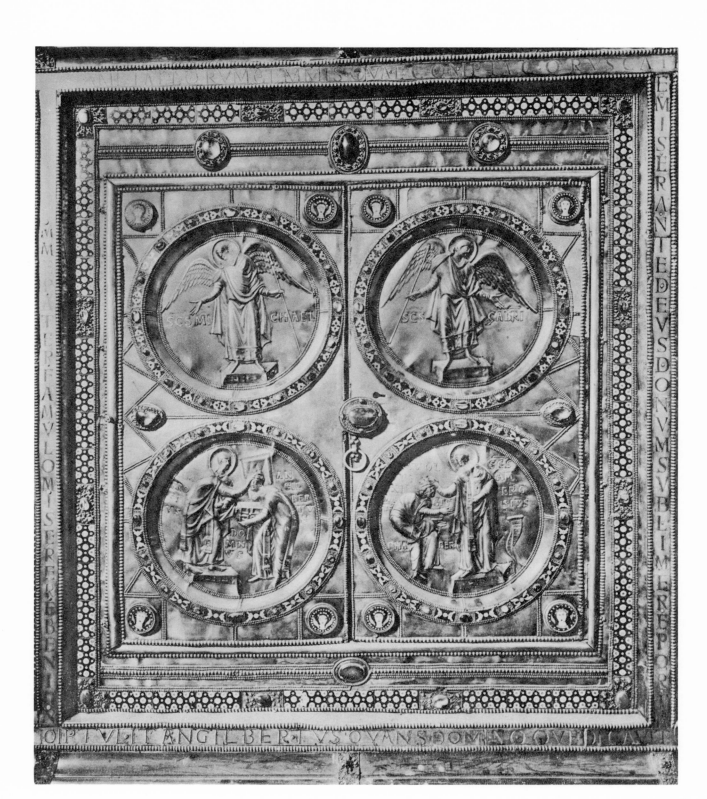

73

MILAN
Sant'Ambrogio
Front gable panel of the ciborium.
Photo Ferrario

74

MILAN
SANT'AMBROGIO
Back gable panel of the ciborium.
Photo Ferrario

75

MILAN

TREASURY OF THE CATHEDRAL

Ivory holy-water stoup of the family of Archbishop Gottofredo.

Photo Ferrario

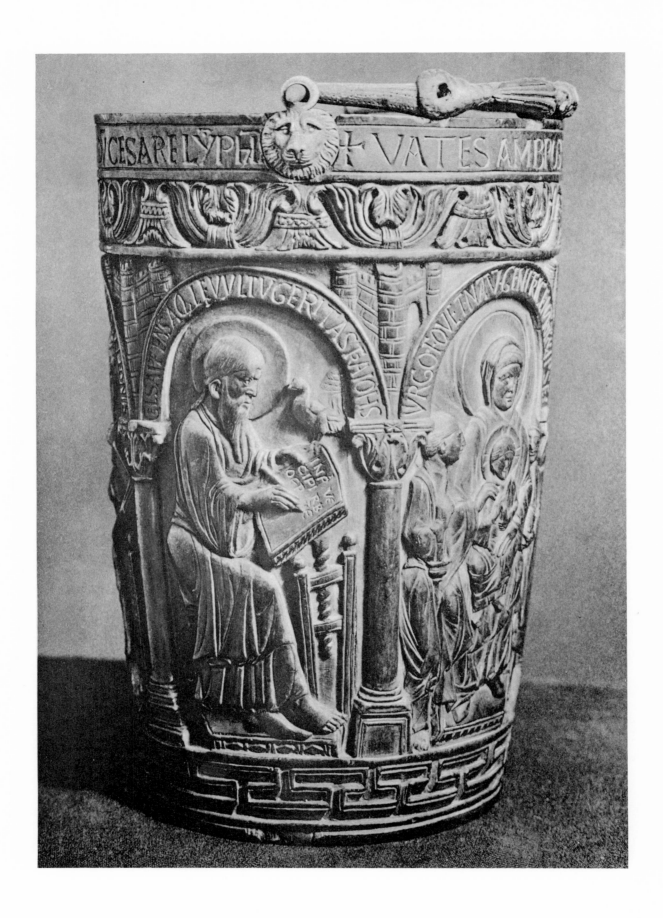

76

MILAN
COLLECTION OF PRINCE TRIVULZIO
Ivory relief of the family of Emperor Otho.
Photo Rossi

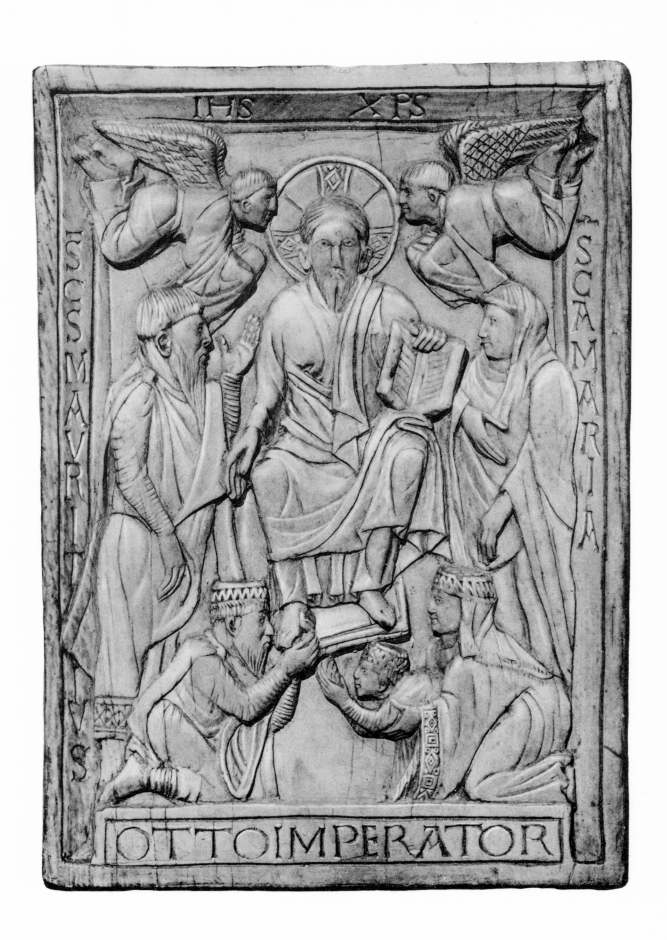

IHS XPS

SCS MAVRITIVS SCA MARIA

OTTO IMPERATOR

77
CIVIDALE
MUSEUM
Ivory tablet of Duke Ursus.
Photo O. Böhm

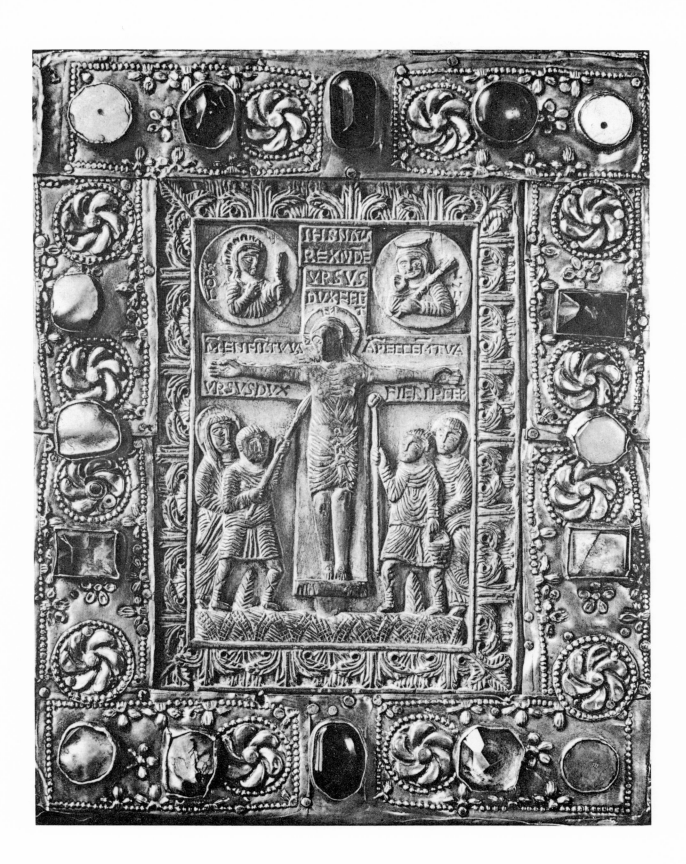

78

ROME
VATICAN MUSEUM
Ivory diptych from Rambona.
Photo Sansaini

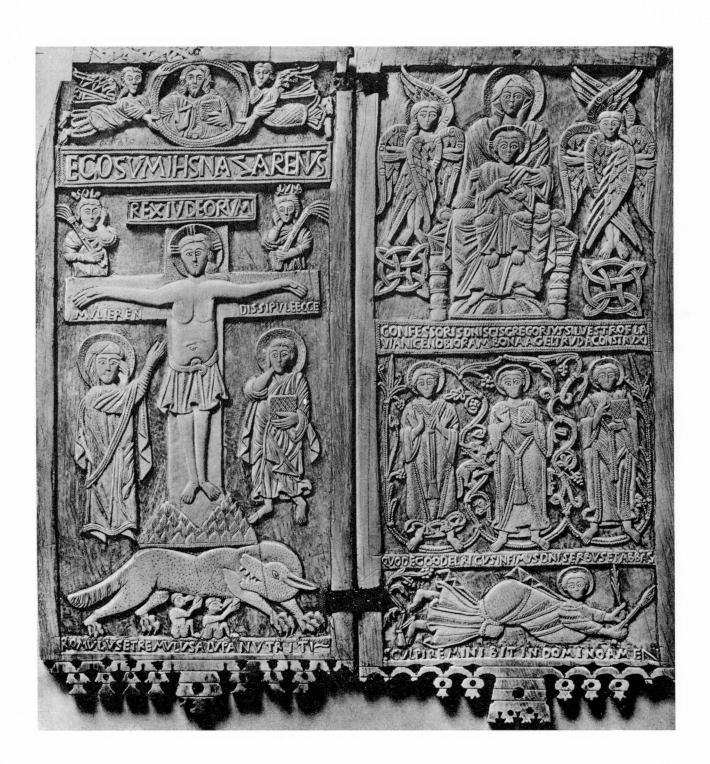

79

TORCELLO
CATHEDRAL
Choir-screen panels.
Photo Alinari

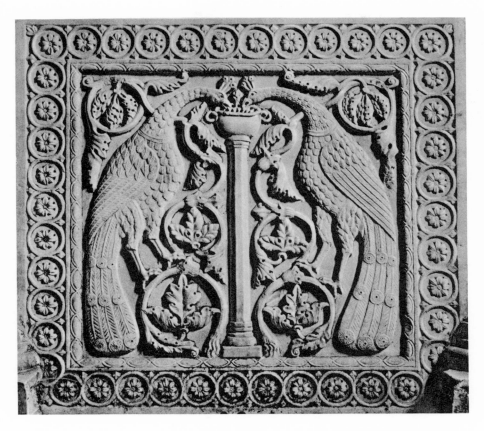

80

TORCELLO
CATHEDRAL

Choir-screen panel with a representation of Kairos.
Photo Alinari